IMAGES of America
LGBTQ+ LONG BEACH

LGBTQIAP+
& THEIR MEAININGS

The initialism continues to evolve so more identities are included!

- **L** — **Lesbian.** A female who is romantically or sexually attracted to another female.
- **G** — **Gay.** A male who is romantically or sexually attracted to another male.
- **B** — **Bisexual.** A person who is romantically or sexually attracted to two or more genders.
- **T** — **Transgender.** A person whose gender identity differs from their assigned gender at birth.
- **Q** — **Queer or Questioning.** A person who is exploring their gender, sexual identity, and sexual orientation.
- **I** — **Intersex.** A person whose sexual anatomy differs from the traditional definitions of male and female.
- **A** — **Asexual or aromantic.** A person who isn't romantically or sexually attracted to other people.
- **P** — **Pansexual.** A person who is romantically or sexually attracted to all people, no matter their sex or gender identity.
- **+** — **Plus Sign (+).** A representation of other gender and sexual identities that aren't included in the initialism.

Throughout the book, there are varying references to LGBT, LGBTQ, LGBTQA+, and LGBTQPAI+. Initialism was adopted at different times since the 1970s. This graphic explains what each of the initials mean. (Author's collection.)

ON THE COVER: Members of the LBGTQ Center Long Beach's Mentoring Youth Through Empowerment (MYTE) program march in the Long Beach Pride Parade behind the Center's banner. (Courtesy the LGBTQ Center Long Beach.)

Images of America
LGBTQ+ Long Beach

Gerrie Schipske
Foreword by Billie Jean King

Copyright © 2024 by Gerrie Schipske
ISBN 978-1-4671-6134-3

Published by Arcadia Publishing
Charleston, South Carolina

Printed in the United States of America

Library of Congress Control Number: 2024930308

For all general information, please contact Arcadia Publishing:
Telephone 843-853-2070
Fax 843-853-0044
E-mail sales@arcadiapublishing.com

Visit us on the Internet at www.arcadiapublishing.com

*To Flo Pickett, thank you for the wonderful history
we have made together since 1979!*

Contents

Foreword & Acknowledgments		6
Introduction		7
1.	Long Beach, Land of the Tongva and *Joyas*	11
2.	Social Vagrants and Female Impersonators	17
3.	Hey Sailor, Are You New in Town?	27
4.	Here Come the Lesbians	35
5.	Briggs Brought Us Out	49
6.	We Love a Parade	57
7.	People Are Dying. Does Anyone Care?	69
8.	LGBTQA Politics	79
9.	So Many Rainbow Heroes	95
10.	Creating a LGBTQA Cultural Center	119
LGBTQ Resources		126

Foreword

Dear Readers,

It is a privilege to be a native of Long Beach, California. Thanks to the people of Long Beach and having free access to public recreation programs, especially free coaching from Clyde Walker, I was able to get my start in tennis, and it shaped and changed my life forever.

Over the course of my life, I struggled with the realization that I was gay, and like so many others from our generation, I lived in a world of fear and shame, understanding that I would not be accepted if I revealed my true self. Not being able to live authentically was a sad reality, but back then, it was a very real thing.

Over the years, both Long Beach and I have changed. Long Beach has become a wonderfully diverse and welcoming city with a vibrant LGBTQ community. The Long Beach LGBTQ community fought for equality and to save lives during the AIDS crisis. It stood up against hate, produced leaders to serve in public office, and to this day, enriches so much of the city. All of this history is reflected in *LGBTQ+ Long Beach*.

It is so important that we know and embrace our community's history, because the more you know about history, the more you know about yourself, and the more it helps you shape the future.

—Billie Jean King

Acknowledgments

We acknowledge that Long Beach is on the land of the Tongva/Gabrieleño and the Acjachemen/Juaneño Nations, who have lived and continue to live here. We recognize the Tongva/Acjachemen Nations and their spiritual connection as the first stewards and the traditional caretakers of this land. We thank them for their strength, perseverance, and resistance.

A very special thank-you to Justin Rudd, who so generously shared his collection of photographs. Thank you to the Historical Society of Long Beach and its executive director, Julie Bartolotto, for providing space for LGBTQ archives and holding the Coming Out in Long Beach exhibition documenting the history of our Long Beach LGBTQ community. It featured their struggles and triumphs on their way to becoming a respected segment of the city's richly diverse citizenry. Also, thank you to both Phillip Zonkel, publisher of *Q Voice News*, and the members of Long Beach Pride, who provided photographs and their historical memories.

Introduction

No single book could possibly include all the Long Beach LGBTQ heroes living and deceased. There are so many people who worked, often behind the scenes, to improve the lives of other LGBTQA and the community of Long Beach in general. This book provides a glimpse into their history.

Today, Long Beach is one of the most LGBTQ-friendly cities in the United States—but this was not always the case.

The land now called Long Beach is the ancestral and sacred ground of the Tongva nation. The Spanish took the Tongva land, renamed the people Gabrielino-Tongva, and worked them as slaves at the Mission San Gabriel. Their nonbinary people were renamed *joyas*, or "jewels."

When Mexico won independence from Spain, it parceled the land into ranchos. Rancho Los Alamitos contains the Tongva sacred place of Puvunga. Midwestern Anglos purchased the land. Some formed the California Immigrant Union (CIU) with the railroads to resell land to "good Christians." CIU manager William Willmore established the American colony and prohibited the sale of liquor in the land deeds. Willmore failed and sold the land to real estate developers, who named the area Long Beach.

Long Beach began changing in the early 1900s when a pier and amusement area—"The Walk of a Thousand Lights"—were constructed and the Pacific Railroad trolleys connected Long Beach to Los Angeles. Visitors came to see a bathhouse, live theaters, and moving picture shows where female and male impersonators, such as Julian Eltinge, performed to sold-out crowds.

Louis Napoleon Whealton brought Tammany Hall–style politics from New York and was elected mayor in 1913. He took money from the city treasury and then devised a plan to repay it and make a name for himself. After firing the chief of police, he directed the acting chief to hire two "special officers," who received bounties for every "social vagrant" they arrested. "Social vagrancy" was used to prosecute homosexual behavior because the felony of "sodomy" did not include oral sex.

The local newspaper would not publish information on the 31 men arrested, so a reporter leaked details to the publisher of the *Sacramento Bee*. The reporter claimed the arrestees belonged to "secret clubs" where the men wore women's clothes, wigs, and makeup and had orgies without women. No secret clubs were ever located.

When Herbert Lowe, a popular florist, demanded a trial, the *Los Angeles Times* published the names of all of the men arrested. Within hours of reading his name, John Lamb, one of the founders of St. Luke's Episcopal Church, committed suicide. An all-male jury acquitted Lowe, enraging the publisher of the *Sacramento Bee* to push lawmakers to add oral sex to the felony of sodomy.

Over a hundred years later, in 2016, a superior court judge called out Long Beach for discriminating against gay men by using undercover police to target them in park restrooms.

Long Beach's relationship with the US Navy began in 1908 when part of the Great White Fleet ported offshore. More than 50,000 residents hosted the sailors at a number of events. After the USS *New Jersey* sailed to San Francisco, two sailors were arrested for sodomy.

The Navy, and later, aviation, brought people from all parts of the United States to live in the city then nicknamed "Queen of the Beaches." Social roles changed. Women joined the military or held men's jobs in factories. Some formed lesbian relationships.

Homosexuality became an issue in the 1950s when the US government revoked clearances charging that homosexuals were "security risks."

In response, the Mattachine Society organized nationally. Several gay men met in a private home and formed the Long Beach Area Council of Mattachine Society, Chapter No. 113 in 1953.

The Satyrs Motorcycle Club was also formed in 1954 with veterans from Long Beach and Los Angeles. Few knew the bikers were gay, which provided an opportunity to socialize free of harassment.

Gay sailors continued seeking companionship at local bars, resulting in the Navy filing a complaint against the city in the 1960s alleging "homosexual civilians" were preying upon young sailors as they came on shore for leave. A local columnist criticized the police for not doing enough to stop Long Beach from becoming a "paradise for pansies."

In 1968, patrons of the Patch in Wilmington (a few miles from Long Beach) owned by Long Beach resident, Lee Glaze, staged a protest at the Harbor Police Station after two patrons were arrested. Ten months later, patrons at the Stonewall Inn in Greenwich Village, New York, fought back against a police raid, sparking a national movement.

The National Organization for Women (NOW) was established in 1966. Within three years, Betty Friedan, one of NOW's founders, called the growing number of lesbians the "lavender menace" and a distraction from efforts to gain rights for women.

Long Beach NOW began in the early 1970s with an office at 1515 East Broadway. It took eight years before NOW supported lesbian rights. But it was the women's movement that pushed lesbian rights forward.

In 1975, Southern California Women for Understanding (SCWU) started in Los Angeles as support for a male group, Whitman-Radclyffe. SCWU developed into one of the largest lesbian organizations in the United States by 1986. Its annual Lesbian Awards dinner in 1987 honored the five pioneers of women's music: Cris Williamson, Teresa Trull, Linda Tillery, Holly Near, and Meg Christian, who performed the very popular "Here Come the Lesbians, the Leaping Lesbians."

The Sojourner Bookstore opened at 535 Redondo Avenue in 1974. Carol Irene and Maria Dominguez said the bookstore provided a place where women could browse, talk, enjoy, and "take time to be." Sojourner's meeting room offered pillows on the floor, hot water for tea, and a bulletin board with posted events and meetings.

Sojourner attracted young feminists because it sold the required textbooks for the California State University, Long Beach (CSULB) women's studies. Consequently, women's studies and the bookstore were targeted by conservatives who claimed both were a "hotbed of lesbians." Eagle Forum planted students in classes and scoured the women's center and Sojourner in search of flyers advertising lesbian events. They presented their "evidence" to the city government and stopped the establishment of a women's commission. The local state senator investigated and called for the total restructuring of the program to include more traditional views of women. Several members of Women's Studies with the help of the American Civil Liberties Union (ACLU) sued in 1982. They won in 1991.

Around the corner from Sojourner was Long Beach's first lesbian bar, the Que Sera, at 1923 East Seventh Street. Musician Melissa Etheridge credits the bar for her start. It was owned by Ellen Ward, who later served on Signal Hill City Council. Lesbians seeking social events outside bars, participated in the Women's Union, attending gatherings and picnics in the local parks.

The Gay & Lesbian Student Union (GLSU) offered students weekly meetings and social events in the early 1970s. GLSU sponsored the first campus "Coming Out" day in the early 1980s. During the AIDS crisis, students and faculty offered education tabling on AIDS/HIV and safer sex. A CSULB LGBT Resource Center opened in 1989.

CSULB's only LGBTQ social fraternity began in 1990 as Delta Lambda Phi's Rho Chapter. In the mid-1990s, Dr. Lester Brown, a gay/two-spirit American Indian, chaired the American Indian Studies department. The first CSULB Lavender Graduation was organized on May 12, 2007.

Singer Anita Bryant and her husband, Bob Green, helped repeal the Miami-Dade County, Florida, homosexual rights ordinance. California state senator John Briggs enlisted Bryant's help

as he launched Proposition 6, a ballot initiative to legalize discrimination against gay teachers. The Briggs Initiative mobilized the LGBT community to come out in a way that had not happened before and resulted in a resounding defeat to Briggs.

Long Beach Lambda Democratic Club was formed to register voters against Briggs. The organization successfully advocated for the passage of an anti-gay employment discrimination and an anti-AIDS discrimination ordinance. Lambda was a catalyst for gay and lesbian candidates running for public office.

In the 1970s, there were 40 gay bars, including Executive Suite, Que Sera, Ripples, Lil' Lucy's, the Ritz, the Stallion, Jim's Corral, Mineshaft, and Sam's Place. Lambda and 35 gay bar owners, known as a "homosexual guild," confronted the Long Beach Police for failing to respond to attacks on patrons and for selectively enforcing "lewd behavior" against homosexuals.

The International Imperial Court of Long Beach, Inc. (IICLB; also known as the Long Beach Imperial Court) was formed in 1971 to raise money for charitable causes.

ONE in Long Beach started as informal living room discussions in 1977 and eventually became the LGBTQ Center Long Beach.

Cherry Avenue and Tenth Street became the first location for the Center. In 1984, the agency created the only HIV and AIDS case management service in Southern Los Angeles County. The Center purchased its current location, a vacant Security Pacific bank building at Cherry Avenue and Fourth Street, in 1986. The first AIDS Walk in Long Beach was held in 1987 and continues today as a separate foundation. The LGBTQ Center provides several programs and a meeting place for LGBTQ organizations.

In 1983, Marilyn Barlow, Judi Doyle, and Bob Crow gathered at Executive Suite on Pacific Coast Highway and Redondo Avenue. They talked about Long Beach needing a lesbian and gay parade and festival and began Long Beach Lesbian & Gay Pride Inc.—now simply known as Long Beach Pride.

Starting a parade was not easy. The gay bar owners did not want a parade, especially on Broadway. The city required $1 million in liability insurance coverage and costs for police and public works. The parade was held after the ACLU requested an injunction and followed up, suing the city for discrimination and making insurance requirements the same for all groups.

The inaugural pride parade and festival were held in 1984. The first parade lasted 30 minutes, drawing a small crowd and a handful of anti-gay protestors. The festival drew even more.

The next year, Judi Doyle received an anonymous phone call threatening violence at the parade. The police told her to wear a bulletproof vest if she was marching.

For 35 years, the parade and festival were scheduled for May. In 2023, the events were moved to August, and more than 40,000 lined Ocean Boulevard to celebrate the 40th anniversary of Long Beach Pride. In 2024, the parade and festival were returned to the month of May.

The Long Beach Dyke March was organized in 2013 by the Long Beach–based Artful Thinking Organization, a nonprofit raising awareness for the prevention and treatment of HIV/AIDS and Breast Cancer. The march happens annually before the Pride Parade with a rally at Bixby Park.

AIDS killed thousands due to governmental indifference and homophobia. The disease was quickly classified as Gay-Related Immune Deficiency (GRID) and ignored as a public health crisis. In 1983, the Long Beach Department of Health and Human Services (LBDHHS) began tracking cases through its AIDS Project coordinated by Ray Kincaide. Twenty-three Long Beach men died that year from AIDS. LBDHHS continues to be a leading provider of HIV medical services.

St. Mary Medical Center was the first to provide care and treatment through its Comprehensive AIDS Resource and Education (CARE) Program in the 1980s. The program expanded and offers health education, HIV/AIDS, and hospital services for people of all ages in Los Angeles County.

Many lesbians stepped up to help their gay friends with AIDS. Margo Martinez, a member of Christ Chapel Church of Long Beach, assembled food baskets. That project was turned into the AIDS Food Store which still operates on Willow Avenue.

Frustrated by the lack of government help, a Long Beach chapter of ACT UP (AIDS Coalition to Unleash Power) protested in the 1989 Long Beach Pride Parade.

The NAMES Project Foundation launched the AIDS Quilt project. In 1991, panels of the AIDS quilt were placed on display aboard the *Queen Mary*.

As of 2024, Long Beach has one of the highest HIV infection rates in Los Angeles County.

Realtor Richard "Dick" Gaylord was the first LGBTQ candidate to run for city council in 1982. Seventeen years later, Dan Baker, a US Customs agent, and Robert Fox, a small-business owner, ran for city council. Baker won and remained on the city council after losing the race for mayor in 2002. He resigned from the city council in 2006.

Nurse, attorney, and educator Gerrie Schipske is the first and only lesbian in Long Beach to win elective office. She won a seat in 1992 on the Long Beach Community College Board of Trustees. Schipske won the 5th Council District in 2006 and 2010.

In 1996, Rick Zbur was the first gay man in Long Beach to run for Congress. He later moved to Santa Monica and was elected to the State Assembly in 2022.

Patty Moore and her partner, Jean Shapen, owned Details, a popular bar on Broadway. Patty was the first lesbian to run for city council in 1994.

In 2006, the Third Council District was contested by lesbian Attorney Stephanie Loftin and four opponents, including community activist and fellow gay Justin Rudd. Loftin defeated Rudd and two others but lost in the general election.

Former CSULB student body president and head of the college Young Republicans, Robert Garcia was elected to city council in 2009 and became Long Beach's first gay mayor in 2014. In 2022, he was elected as a Democrat member of Congress.

In 2012, the city repurposed a promenade area downtown and dedicated it as Harvey Milk Promenade Park and Equality Plaza. The park was the first named for the San Francisco politician who was assassinated in 1978. Name plaques are added each year to the walls in Equality Plaza to honor Long Beach–area LGBTQ leaders.

Long Beach first acknowledged its hometown Wimbledon tennis star, Billie Jean Moffitt King, in 1968 by dedicating a city tennis center at Tenth Street and Park Avenue. In 2019, the city named the new main library the Billie Jean King Library, which was dedicated by King and her partner, Ilana Kloss.

The city has added rainbow lights to public buildings and painted crosswalks in a proposed LGBTQ+ Cultural District. It continues to earn a perfect score on the Human Rights Campaign Municipal Equality Index.

One
LONG BEACH, LAND OF THE TONGVA AND JOYAS

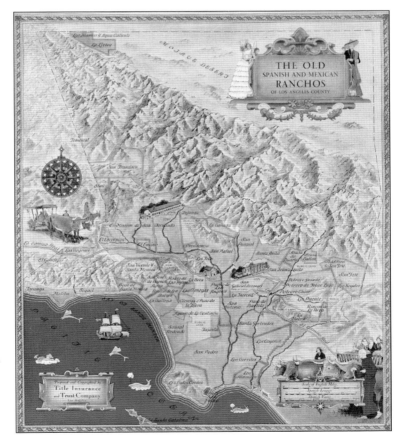

The map shows the land of the Tongva in Southern California. Their sacred site, Puvunga, is located on Rancho Los Alamitos, which is now called Long Beach. The land was taken by the Spanish, who enslaved the people to build the missions. The Tongva built the Misión de San Gabriel Arcángel and were renamed the Tongva/Gabrieleño, by the Spanish. (Library of Congress.)

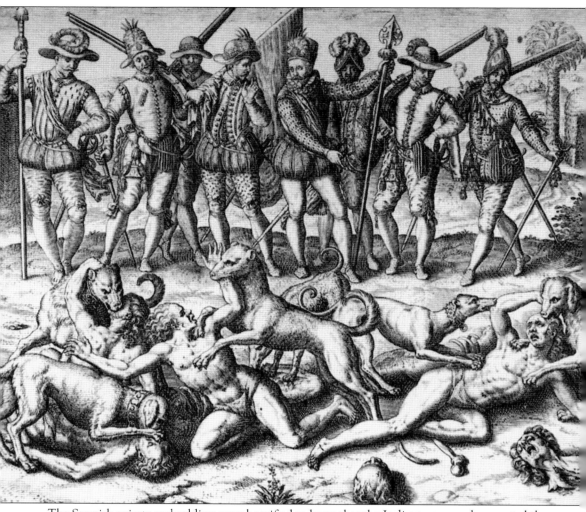

The Spanish priests and soldiers were horrified to learn that the Indigenous people accepted three genders: male, female, and nonbinary. The priests named the third-gender *joyas* (jewels). It is not clear if the term was used sarcastically or in acknowledgment of the esteemed stature given to them by their own people. A report to the king warned of "substantial evidence that those Indian men who, both here and farther inland, are observed in the dress, clothing, and character of women—there being two or three such in each village—pass as sodomites by profession. . . . They are called *joyas*, and are held in great esteem." The etching by Theodor de Bry shows early Spanish soldiers killing Indigenous men who were accused of committing sodomy. Recent academic research suggests that the Spanish were determined to eradicate the *joyas*. (Library of Congress.)

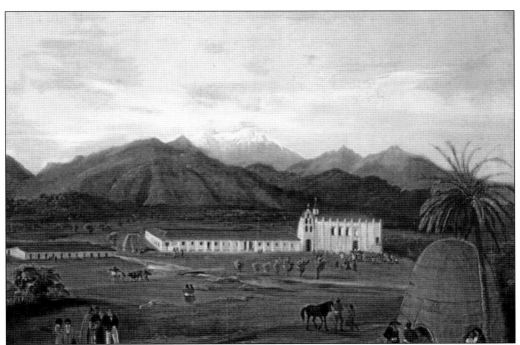

Fr. Junipero Serra established the Misión de San Gabriel Arcángel (above) on September 8, 1771, the fourth of the 21 missions built by Indigenous labor. Although more than 5,000 Indigenous lived on the land and referred to themselves as Tongva ("people of the earth"), the Spanish renamed them after the mission. The Spanish forcibly baptized the Indigenous and gave them Spanish names. The Native languages were also erased by the Spanish, and the people were required to speak Spanish. This effectively erased genealogical information that could be used to later trace ancestry. The photograph below shows a rock marker for the village and sacred site of the Gabrieleno Tongva known as Puvunga. It is located on land now occupied by Rancho Los Alamitos and California State University, Long Beach. (Above, Library of Congress; below, Gabrieleno Tongva.)

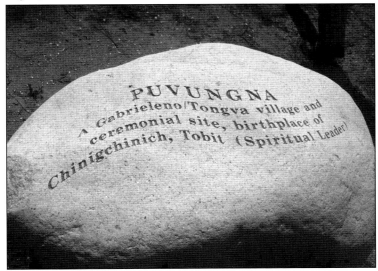

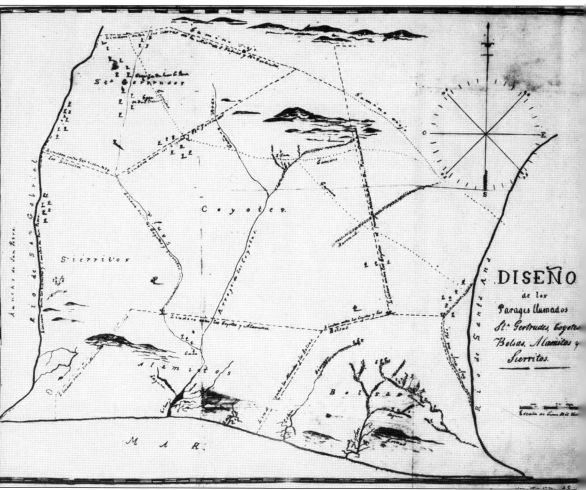

After Mexico's independence from Spain in 1821, it presented land to Jose Miguel Nieto. With his death, it was divided into "ranchos" Los Cerritos, Los Alamitos, San Gertrudes, Los Coyotes, and Las Bolsas, as shown in the 1894 map. Los Alamitos was later purchased by Don Abel Stearns, then Michael Reese, and finally John W. Bixby. Los Cerritos was purchased by Don Juan Temple and then Jotham Bixby. Jotham joined the railroad California Immigrant Union, which sold land to "good Christians who would preserve the homogeneity of our people." CIU manager William Erwin Willmore contracted with J. Bixby & Company to develop a farming colony and a town site, named the American Colony Tract. It was renamed Willmore City by a newspaper reporter. All land deeds prohibited liquor in order to attract the Methodist and temperance communities. Willmore eventually failed and sold out to developers who renamed the land Long Beach at the suggestion of Belle Lowe. (Library of Congress.)

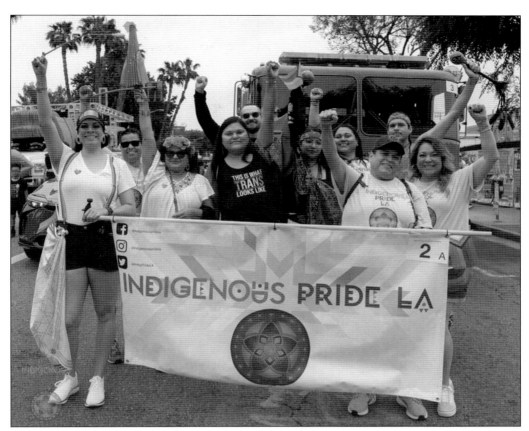

October 11 is both Indigenous People's Day and National Coming Out Day. In 2017, Indigenous Pride LA was formed to celebrate two-spirit, Indiqueer, and Indigenous LGBTQPIA+ culture, identities, and heritage. The City of Angels Two-Spirit Society (CATSS) began in late 2012 by a diverse group of Native American LGBTQ peoples in the Los Angeles Basin on Tongva territory. While the Red Circle Project of AIDS Project Los Angeles provided exclusively Indigenous gay male and trans feminine social and educational spaces, the community voiced a need for a CATSS space inclusive of Indigenous lesbian and bisexual women and the diverse families of CATSS members. The LGBTQ Center Long Beach has hosted subsequent meetings. (Both, the LGBTQ Center Long Beach.)

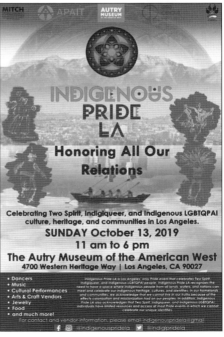

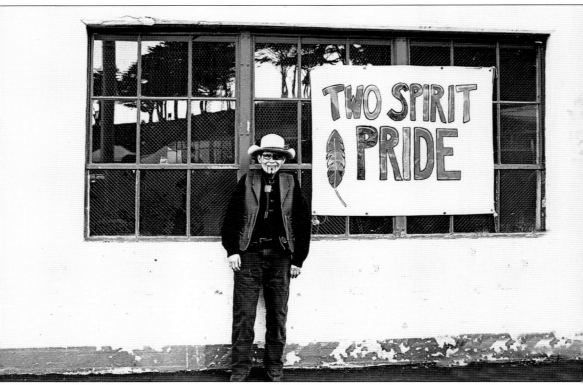

In 2019, L. Frank provided a Tongva blessing for the 2019 Los Angeles Pride Parade and Festival. L. Frank (born in 1952) is the nome d'arte of L. Frank Manriquez, a Tongva-Ajachmem award-winning artist, writer, tribal scholar, cartoonist, and Indigenous language activist. Frank identifies as "two spirit," a contemporary term for Indigenous peoples who live outside the gender binary or who are not heterosexual or cisgender. L. Frank refers to themself as "two spirit" because it "more appropriately defines that I am more than a sexual being. I'm a sentient and spiritual being." The term was proposed in 1990 during the Third Annual Intertribal Native American, First Nations, Gay, and Lesbian American Conference. L. Frank's pronoun is pó. L. Frank cofounded the Advocates for Indigenous California Language Survival to combat erasure and previously served on the board of the California Indian Basket Weavers Association and the Cultural Conservancy. (L. Frank.)

Two
Social Vagrants and Female Impersonators

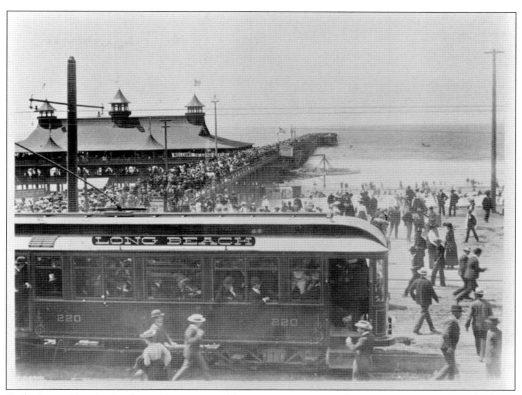

Early Long Beach Anglo settlers were older, conservative, and pro-temperance. Hundreds of Methodists came each year to the Chautauqua bible summer camp. Long Beach changed as the railroads built connections. In 1902, more than 50,000 arrived for the opening of the Pacific Electric Railway from Los Angeles to the corner of Ocean Park and Pacific Avenues. (Author's collection.)

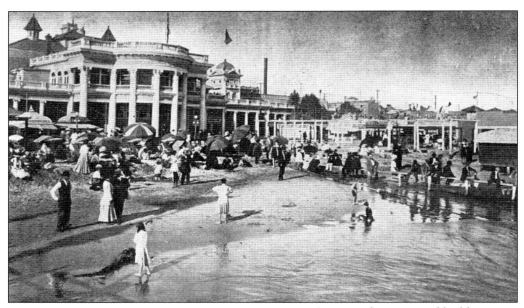

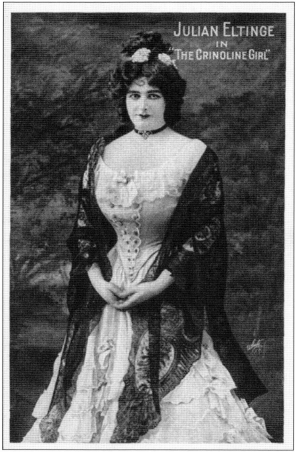

A pier, auditorium, and bathhouse (above) catered to the growing number of visitors. A Walk of a Thousand Lights, signifying the thousand incandescent white and purple lights that lined the area, created a carnival-like atmosphere. The walk offered live theaters and, later, moving picture shows, which often featured female and male impersonator performances. Famed female impersonator Julian Eltinge performed several times in the early 1900s to sold-out crowds in Long Beach. Women particularly liked Eltinge because they felt he "understood women more than any man." Newspapers carefully noted how "masculine" Eltinge was in real life so as not to raise questions about his sexuality. (Above, author's collection; left, Library of Congress.)

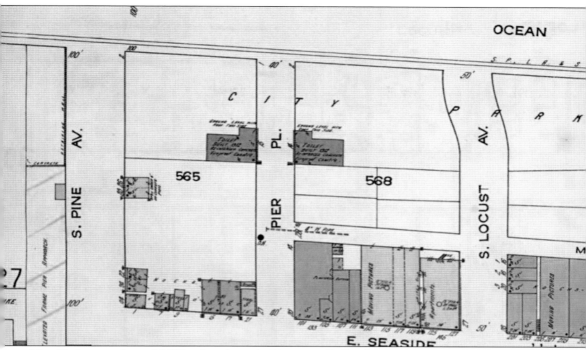

New York native Louis N. Whealton brought Tammany Hall politics to Long Beach when elected as mayor in 1913. He took money from the city treasury to fund "secret police" activities. He replaced the chief of police and directed acting chief C.C. Cole to hire two "special officers" to entrap the "social vagrants" who used the newly built "comfort station" (above) near the pier. Catching them in the urinals, the officers would mark their private areas with indelible ink and then receive a $10 bounty for their arrest. "Social vagrancy" described homosexual behavior and was punishable by a fine of $300 to $500 or six months in jail. The felony "sodomy" did not include oral sex. The "special officers," W.H. Warren and B.C. Brown, arrested 31 men, including John A. Lamb, a churchman who helped found St. Luke's Episcopal Church, and Herbert Lowe, a popular florist. This image is from Sanborn Insurance Maps, 1914 (Library of Congress.)

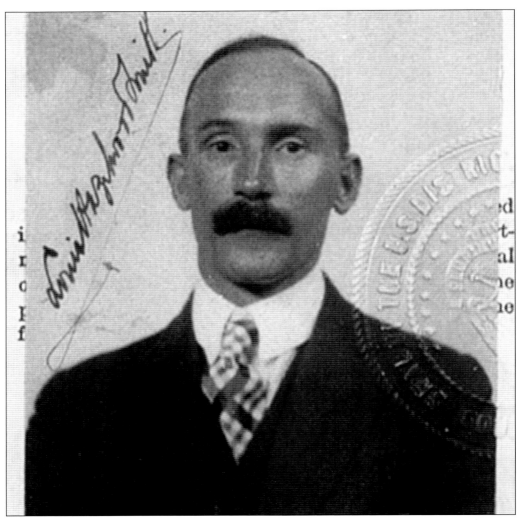

Although there are no photographs of John A. Lamb, national newspapers wrote extensively about him. Lamb was a pharmacist from Scotland who relocated to San Bernardino, California, because of his mother's ill health. He successfully owned a pharmacy which he sold and moved to Long Beach, where he reopened his shop on Pine Avenue. He spent much of his free time helping St. Luke's Episcopal Church grow from a "mission" to a parish. Lamb developed a close relationship with Louis Hazelwood Smith (pictured), a realtor and fellow member of the church vestry. The two often sang together at social and church events. Lamb sold his pharmacy and joined the board of directors of the Long Beach Savings & Trust Bank. He was arrested by the "special officers" outside the newly constructed "comfort station" located near the beginning of the pier. Lamb protested his innocence, pled guilty, and paid a $500 fine instead of facing a trial. (National Records Administration, U.S. Passport photographs.)

After reading his name in the morning newspaper, John Lamb took a trolley to San Pedro, where he purchased cyanide of potassium from a pharmacist colleague. He got back on the trolley, arrived at Point Fermin, walked out on the rocks, and swallowed the poison, dying quickly. In his pocket was a note to his sister Marion, in which he professed his innocence and named L.H. Smith as being behind the politics of his arrest. Only the *San Pedro Daily Pilot* reported Smith's name in the suicide note. Lamb was denied funeral services inside the church because of his suicide. However, dozens of church members and clergy attended services on November 16, 1914, at the home he shared with his sister, Marion, located on Broadway. The Reverend Arnold Bode, pastor of the church, for whom John had sung his last solo, officiated with the two former rectors of the church: Rev. Charles T. Murphy and Rev. Robert Gooden. (Los Angeles County Public Records.)

News of the arrests did not appear in the local press until Herbert Nelson Lowe demanded a trial. Unlike the other men arrested in and around the comfort station, Lowe was entrapped on his own property. Lowe hired attorney Roland Swafford to defend him by laying out for the all-male jury, how Lowe rented a back house to B.C. Brown, one of the police "special officers" sent to entrap him. Brown arranged for other police officers to spy through a hole in a wall and outside the house while he lay in bed. Brown claimed Lowe kissed and fondled him on two occasions. Lowe denied the allegations. Warren and Brown testified that after they arrested Lowe, he confessed to going to social clubs that were called "drags" and whose members were known as "queers." Lowe vehemently denied there were any clubs, and the police never found any. This image is from an issue of *Long Beach Press Magazine* published in 1924.

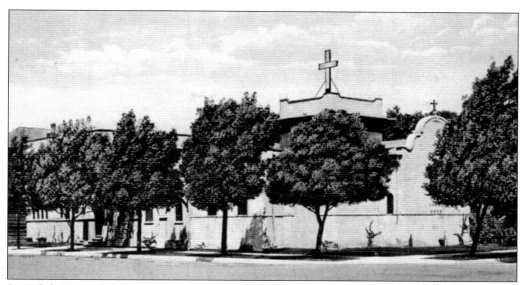

St. Luke's Episcopal Church began as a "mission" in Long Beach in 1897 with services being held in the Long Beach Masonic Hall. The church was rebuilt at Atlantic Avenue and Seventh Street from funds realized with the sale of the former location to the First Christian Church. On October 18, 1917, the granite cornerstone for the new church and sanctuary was laid under one corner of the 100-foot tower. (Author's collection.)

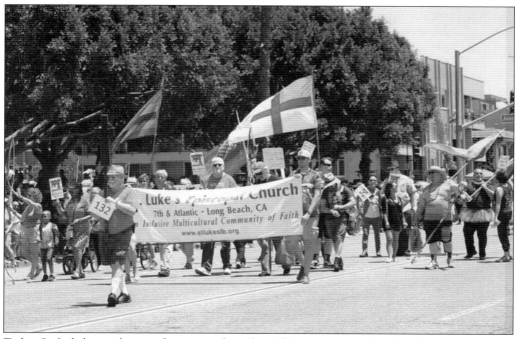

Today, St. Luke's members work on a number of social justice issues and declared the congregation a "sanctuary" for immigrants in 2007. St. Luke's is considered to be one of the most welcoming of the LGBTQ+ community. Every year, as a part of Long Beach's Pride Parade, St. Luke's holds a "Communion on the Bluff," overlooking the ocean to kick off the event. A contingency walk in the parade. (Long Beach Pride.)

C.K. McClatchy (left), publisher and editor of the *Sacramento Bee*, was obsessed with homosexuality. He hired Eugene Fisher, a Long Beach reporter who had once worked for him in Modesto. He asked for any details about Franklin K. Baker. Baker left Sacramento under suspicion and relocated to Long Beach to establish the Unitarian Church. He also became a surrogate speaker for Louis Whealton. In 1913, Baker was arrested outside a shop in Santa Monica for "social vagrancy." He denied inappropriate behavior and asked for a trial, which was never held. Baker and his wife left the area and they eventually traveled abroad selling automobiles. (Left, Library of Congress; right, 1911 *Sacramento Bee*.)

McClatchy was so outraged that Baker escaped punishment and Lowe was acquitted, that he called on his friends in the state legislature to revise the crime of sodomy to outlaw oral sex and increase the penalty to 15 years in prison. In 1919, the California Supreme Court struck down the law because the words for oral sex "fellatio and cunnilingus" were Latin and not understandable by the average citizen. This was published in the *Sacramento Bee* in December 1914.

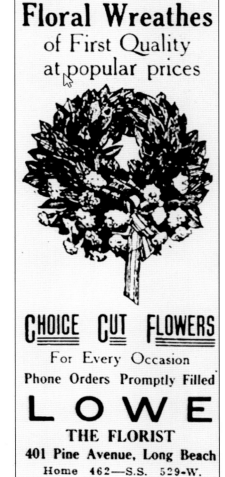

Several newspaper accounts carried Herbert Lowe's supposed confession admitting he had been involved in male relationships for many years before his arrest. He claimed his parents would pay for medical treatment for his "condition" if the case were dismissed. Lowe later denied this confession. After his acquittal, Lowe sent flowers to each of the members of the jury. He stayed in Long Beach and opened a second floral shop. This ad was published in the *San Pedro Daily News* in 1914.

Margaret Louise Fitts Lowe and Herbert were married only six years when they divorced. She was an immensely popular member of the community and was elected the first president of the College Women's Club, the predecessor to the American Association of University Women (AAUW). Lowe was also the best-known West American conchologist. His interest in shells began in his high school days. He began writing about shells in 1899 when *Nautilus* carried his first paper, the account of a dredging trip to Catalina Island, which secured a number of new species. His shell collections are found at the Smithsonian and at the San Diego Natural History Museum. In 1917, he signed up for the draft but never served in World War I. Nothing was ever printed again about his arrest and trial. Lowe died on June 10, 1936, in Long Beach. (National Archives and Records Administration, WWI Draft Registration.)

Three

HEY SAILOR, ARE YOU NEW IN TOWN?

LONG BEACH, CALIF., THURSDAY EVENING, APRIL 23, 1908.

Program for Friday, Long Beach Day

What Will Happen.

10:30—Two five-inning baseball games on high school grounds between nines from the battleships.
10:30 a. m.—Automobile races on the sand.
1:00 p. m.—Nine-mile yacht race from the Long Beach pier. Prize, loving cup from Chamber of Commerce.
2:00 p. m.—Football game between teams selected from the battleships.
2:30 p. m.—Grand concert in Auditorium by Long Beach Municipal Band.
2:30 p. m.—Yacht race. Sack races. Potato races. Obstacle race, and tug of war by the sailors. Prizes.
3:30 p. m.—Drill by marines on high school grounds.
4:00 p. m.—Balloon race between four balloons named respectively, Georgia, New Jersey, Rhode Island and Virginia.
4:30 p. m.—Admiral salute of thirteen guns upon arrival of Admiral and staff and officers. An automobile ride around the city.
8:00 p. m.—Fireworks and grand illumination of entire ocean front.
8:00 p. m.—Special entertainment by Y. M. C. A. at Sun Parlor.
8:00 p. m.—Ball to fleet officers at Hotel Virginia.
9:00 p. m.—Sailors' ball in Auditorium.

The US Navy arrived in Long Beach in 1908 when Pres. Theodore Roosevelt sent 16 battleships and 14,000 sailors dubbed the Great White Fleet to a two-year round-the-world cruise designed to show US naval power. More than 50,000 people came out to celebrate and host the sailors to a number of activities. This was published in the *Long Beach Press* in 1908.

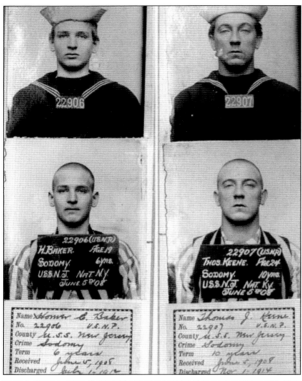

The USS *New Jersey* left Long Beach for San Francisco, where the Navy arrested Homer Baker and Thomas Keene (pictured) on charges of sodomy. They were imprisoned at San Quentin because the Navy lacked a military prison in California. Ironically, six years before his arrest, local florist Herbert Lowe had followed the fleet and wrote several articles for the local press about flowers displayed at the banquets honoring the Navy. (The San Francisco GLBT Historical Society.)

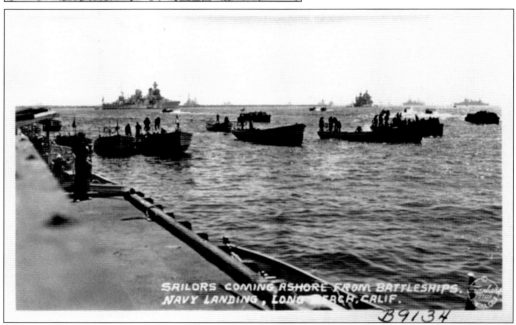

During and after World War II, the city became a social spot for gay sailors who sought companionship at local bars. The city provided landings where ships could unload (pictured). In the 1960s, the Navy filed a complaint with the city claiming homosexual civilians were preying upon young sailors when they came on shore for leave. (Library of Congress.)

City councilman D. Patrick Ahern publicly urged the police department to "rid Long Beach of seven homosexual hangouts." The newspaper would not endorse Ahern for Congress, so he accused the editors of "being soft on homosexuals." However, the same newspaper ran columns criticizing the city for not stopping Long Beach from becoming a "paradise for pansies." This was published by the *Long Beach Independent* in 1966.)

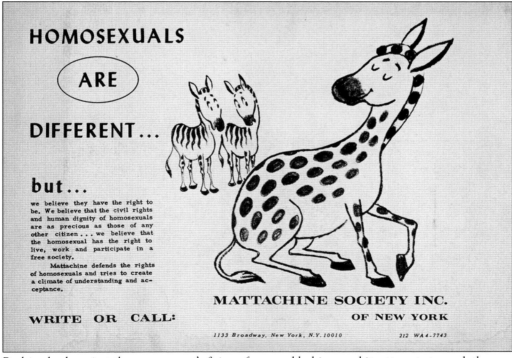

Pushing back against the government's firing of gays and lesbians and its attempts to mark them as "security risks," the Mattachine Society was one of the first groups involved in LGBTQ activism. It began as a secret organization in Los Angeles in 1950 and was founded by Communist organizer Harry Hay and other leftists. (US National Park Service.)

```
                        Long Beach Chapter #
                        Desk Sec.
                        August 26, 1953

Minutes:

     Discussion Group called to order 8:30 P.M.
representatives from Southern Area Council advised
forming a Chapter:
Chapter was formed, the Preamble was read and thirteen
was pleged. Four officers ere elected.
          Chairman  John Ard
          Sec.      Richard Riley
          Treasurer Robert Elliott
          Rec. Sec. Norman Allein
Motion made and second for Chaters name, tie of
six votes each for "Dorian Chapter", six for "Long Beach
Chapter." Tie decided by Chairman in favor of "Long
Beach Chapter." - Delegates nominated to represent
Chapter to Sourthern Area Council meeting Monday
evenings and for a period of one year, hold office.
     Delegates were Chairman John Ard, and Treasurer
Robert Elloitt.
     Dues were descussed. $2.00 each per month.
     Letter of application for Chapter fees. Five
dollars was collected.
     1st and 3rd Thursday nominated for business
meetings. The 2nd and 4th for SPONSORING a discussion
group. Descuission on getting magazines for the
```

Mattachine's stated purposes were "to sponsor, supervise and conduct scientific research in the field of homosexuality; to publish and disseminate the results of such research; and to aid in the social integration and rehabilitation of the sexual variant." Several Long Beach men met at a home at Stevely Avenue to form the Long Beach Area Council of Mattachine Society, Chapter No. 113. Other organizations began in the early 1950s in what is described as the "American homophile movement." Several Mattachine members started ONE, Inc. and published a monthly international magazine until 1967. The US Postal Service tried stopping the mailing of the magazine but the courts ruled in favor of ONE. (Both, ONE Archives at the USC Libraries.)

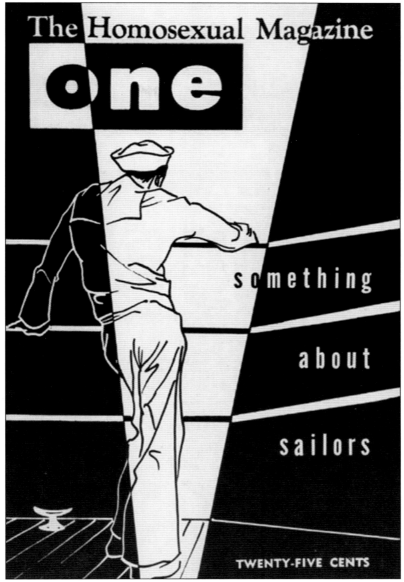

The ONE Archives Foundation, Inc., the oldest active LGBTQ organization in the United States, began as the personal collection of Jim Kepner in 1942. It was later named Western Gay Archives. Eventually, the large collection became the National Gay Archives and then, finally, the Gay & Lesbian Archives. In 2010, ONE Archives Foundation, Inc., deposited its vast collection of LGBTQ historical materials with the University of Southern California (USC) Libraries, becoming the largest collection of LGBTQ+ materials in the world. In 2023, the name was changed to One Institute. One Institute offers education, arts, and social justice programs. Its new website—oneinstitute.org—notes, "Our one-of-a-kind exhibitions and public programs connect LGBTQ+ history and contemporary culture to effect social change. Through unique K-12 teacher training, lesson plans, and youth mentorship programs, we empower the next generation of teachers and students to bring queer history into classrooms and communities." (ONE Archives at the USC Libraries.)

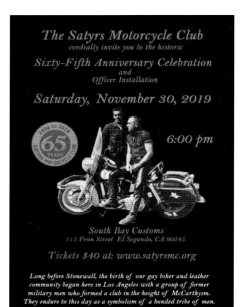

Satyrs Motorcycle Club was organized in 1954 with former military men from Long Beach and Los Angeles. Few knew the bikers were gay, which provided an opportunity to socialize free from harassment. Satyrs is the oldest continuously operating gay motorcycle club in the US. The club holds local and national events with other chapters. (Satyrs Motorcycle Club.)

Military bases often hosted shows with soldiers in drag even after Congress passed the May Act in 1941, authorizing the military to survey and place "homosexual" hangouts near military bases "off limits." The Armed Forces Disciplinary Control Board (AFDCB) listed off-limits places for service members. If found there, they could be arrested, court-martialed, and dishonorably discharged. The bar could lose its license. (National Archives.)

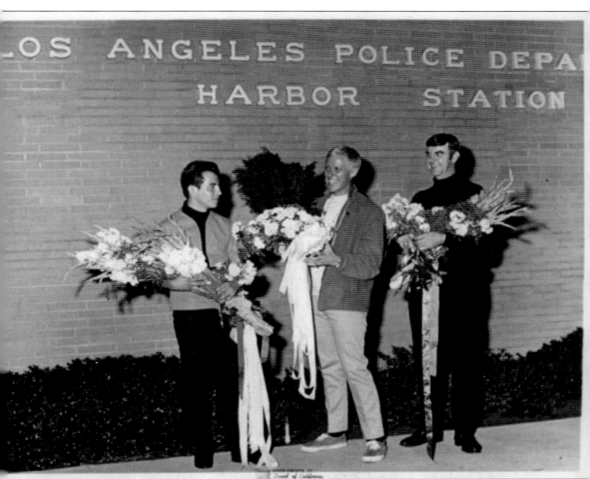

In 1951, the California Supreme Court ruled the Black Cat Restaurant in San Francisco could not lose its liquor license for serving homosexuals. After the ruling, gay bars flourished but police raids continued. The gay community began fighting back. In 1968, patrons of the Patch in Wilmington, owned by Long Beach resident Lee Glaze (center), staged a protest at the Harbor Police Station after two patrons were arrested. As the police took them away, Glaze jumped on stage yelling, "It's not against the law to be a homosexual, and it's not a crime to be in a gay bar!" Glaze rallied his customers to chant, "We're Americans too!" Protestors bought all of the flowers at a local florist and took them to the police station at 3:00 a.m. The police did not know how to respond to the "flower power protest" and released the two. (*Q Voice News*.)

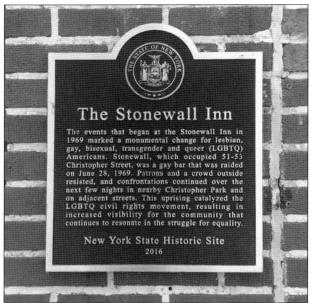

Ten months after the Patch protest, patrons at the Stonewall Inn in Greenwich Village, New York, fought back against frequent police raids. Hundreds of bar patrons and residents from the neighborhood took to the street for six days, forcing the police to barricade themselves inside the bar. The gay community had had enough, and the nation took notice. (Library of Congress.)

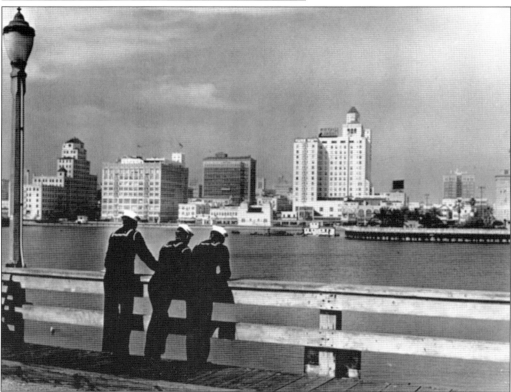

Long Beach was home port for 120 ships and 45,000 Navy personnel. By 1995, the Long Beach Naval Shipyard closed and the steady stream of sailors and the city's Pike amusement area and downtown tattoo parlors were gone. Gay and lesbian bars in Long Beach increased in the 1960s–1980s along Broadway, which today is referred to as the "gay corridor." (Library of Congress.)

Four

HERE COME THE LESBIANS

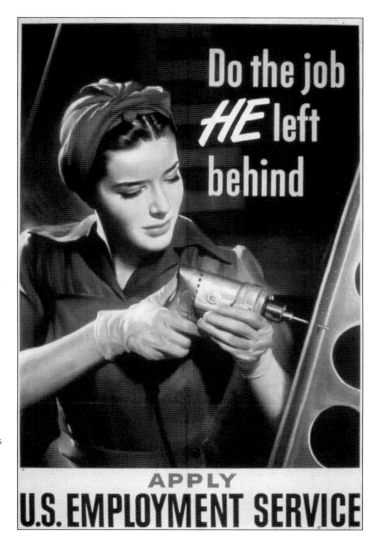

Many women came to Long Beach in World War II to fill male jobs assembling bombers in the Douglas Aircraft plant. Some joined the Women's Airforce Service Pilots (WASPS) and flew the planes off the assembly line to military bases. Others served in the military. The changing of roles opened up possibilities to venture out of what was traditionally female. The message was still clear, however, that lesbianism was not acceptable. (National Archives.)

Homosexuals were declared a threat to national security and barred from employment in 1953 when Pres. Dwight D. Eisenhower signed Executive Order 10450. This "lavender scare" forced newly organized groups to remain secret and their members anonymous, such as the Daughters of Bilitis (DOB). Bilitis is a character in the 1894 poem written by Pierre Louys. She was a contemporary of Sappho on the Isle of Lesbos. DOB started in San Francisco and became the first lesbian civil and political rights organization in the United States. DOB published a monthly newsletter, the *Ladder*. Longtime partners Del Martin and Phyllis Lyon were instrumental in starting and continuing DOB until 1972. Stella Rush and Helen Sandoz organized a Los Angeles chapter of DOB, which published the *Lesbian Tide* until 1980. It was the first magazine to use *lesbian* in the title. (Both, author's collection.)

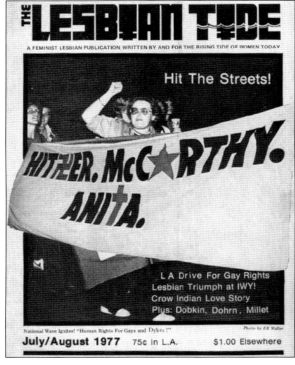

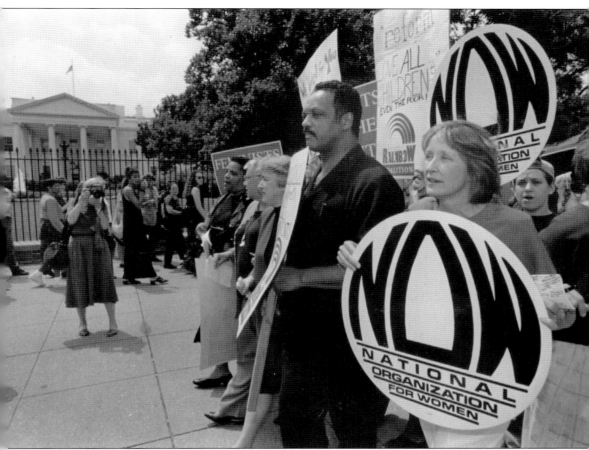

On June 30, 1966, the National Organization for Women (NOW) was established on the proposition that "women, first and foremost, are human beings, who like all other people in our society, must have the chance to develop their fullest human potential." In 1969, NOW president Betty Friedan called the growing number of lesbians in NOW the "lavender menace." She claimed their presence distracted the organization from gaining rights for women, even though Ivy Bottini, a lesbian, designed NOW's logo and lesbian Rita Mae Brown edited the national newsletter. It took eight years before NOW would officially support lesbian rights. The photograph shows NOW president Patricia Ireland (holding logo) joining civil rights activist Jessie Jackson in a protest outside the White House in 1996. Today, NOW has over 500,000 members and is the largest feminist organization in the United States. (Library of Congress.)

NOW

National Organization for Women

P.O. BOX 15306 90813
1515 E. BROADWAY
LONG BEACH
CALIFORNIA
(213) 432-1314

AUGUST 26 A DAY TO CELEBRATE
an editorial from NOW National

AUGUST 26 IS THE DAY ON WHICH 26 MILLION PEOPLE - WOMEN - WON THE RIGHT TO VOTE IN THE UNITED STATES EXACTLY 53 YEARS AGO. BUT BECAUSE WHAT WOMEN DO AND WHAT WOMEN THINK AND WHAT WOMEN ACCOMPLISH ARE USUALLY OMITTED FROM THE HISTORY BOOKS, FEW WOMEN AND EVEN FEWER MEN RECOGNIZE THE DAY'S SIGNIFICANCE.

This was, in fact, the largest single group to win suffrage in the history of the United States. AUGUST 26, 1920, marked the end of a 72-year struggle by generations of American women to win the right to vote--generations of women who literally wore out their lives in successive campaigns; who sacrificed every cent they could lay their hands on as well as their personal reputations to speak in public (absolutely scandalous in 1848 when they began); to petition and picket and demonstrate (outraging public morality and making themselves the targets of physical as well as verbal abuse and assult); and who finally, because they set up six Silent Sentinels at each of the gates of the White House carrying banners that dared to use President Wilson's own eloquent words on self government to plead for their rights in a democracy, went to jail, first for a few days, then for six weeks and later, for six months, for the "crime" of "obstructing sidewalk traffic".

No standard American history textbook details the story of their imprisonment in the then infamous Occoquan Workhouse in Virginia. It's a story that should be told: they were, in fact, among the earliest victims of the abrogation of civil rights in wartime. And when they protested against the illegality of their arrests, the wretched conditions of the prison, and the brutality with which they were treated by going on a hunger strike, they were then subjected to the ordeal of forced feeding. It is significant that in the wake of the public protest that arose as details of their treatment became known, they were unconditionally released, and every single one of their prison sentences and original arrests were invalidated.

It was a bitter price that these generations of American women paid for the right to vote for themselves and for us. They were brave, they were gallant, they were--many of them--brilliant, and they were all extraordinary. They deserve to be honored, but they remain largely unknown.

HOW DO WE HONOR THEM?

WE HONOR THEM FIRST BY PICKING UP THE TORCH AND RENEWING THE STRUGGLE FOR EQUALITY OF OPPORTUNITY AND PARTICIPATION FOR WOMEN IN ALL THE PROCESSES OF OUR SOCIETY. THAT'S WHAT THE NEW WOMEN'S MOVEMENT IS ALL ABOUT. THOSE OF US WHO ARE INVOLVED HAVE DEDICATED OURSELVES TO FINISHING THEIR UNFINISHED REVOLUTION TO ACHIEVE FULL EQUALITY OF CITIZENSHIP, EQUALITY OF OPPORTUNITY, EQUALITY UNDER THE LAW FOR WOMEN. There should be no room in a democratic society for second class because of race, religion, national origin--or sex.

Despite what you read in the paper and see on television, the main issues of the women's movement have little to do with burning bras or hating men. Few women live out their lives in the fairytale that goes "...and she married Prince Charming and moved to his castle and they had beautiful children and lived happily ever after."

con't pg 2

Long Beach NOW started in the early 1970s with an office at 1515 East Broadway. Its members worked for the passage of the Equal Rights Amendment and established the city's first rape crisis hotline to assist victims. Members periodically provided "clinic defense" at local family planning offices. In the 1980s, Long Beach NOW advocated for establishing "nurse sexual assault examiners" and an advisory committee to the chief of police. The chapter also advocated for a sexual assault team to assist victims. A study done by Long Beach NOW in 1990 showed that mayor and council appointments to citizens commissions had a serious "gender imbalance" and called for an increase in appointments of women. Each year, the chapter held a Susan B. Anthony Award Dinner, to honor a woman for making an outstanding contribution to women's rights. (Author's collection.)

In 1976, Betty Berzon and 20 other women started Southern California Women for Understanding (SCWU) as a support group for Whitman-Radclyffe, a primarily male group. SCWU developed into one of the largest non-profit lesbian organizations in the United States by 1986, dedicated to "enhancing the quality of life for the lesbian community and for lesbians nationwide, creative, and positive exchange about homosexuality, and changing stereotypical images of lesbians." The Southern Committee of SCWU, which included Long Beach, first met on December 4, 1978. Judi Doyle was elected Chair on January 6, 1979. SCWU held an annual Lesbian Awards dinner and in 1987 honored the five pioneers of women's music: Cris Williamson, Teresa Trull, Linda Tillery, Holly Near, and Meg Christian. Christian released a record album in 1977 that included "Here Come the Lesbians, the Leaping Lesbians," written by Sue Fink. (Right, author's collection; below, J.D. Doyle.)

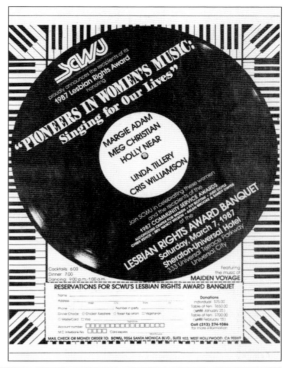

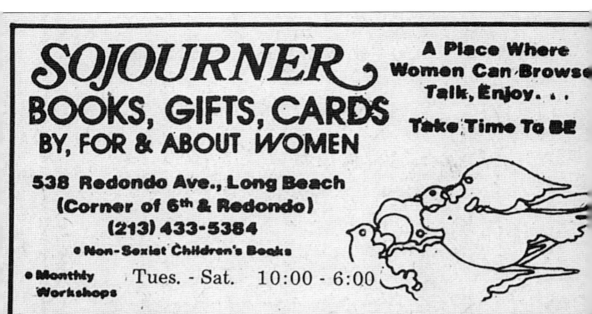

Carol Irene and Maria Dominguez opened Sojourner Bookstore at 535 Redondo Avenue in 1974. Sojourner provided a "place where women can browse, talk, enjoy and take time to be." The store sold textbooks for college women's studies courses and offered a meeting room with pillows on the floor, hot water for tea, and a bulletin board with posted events and meetings. (Author's collection.)

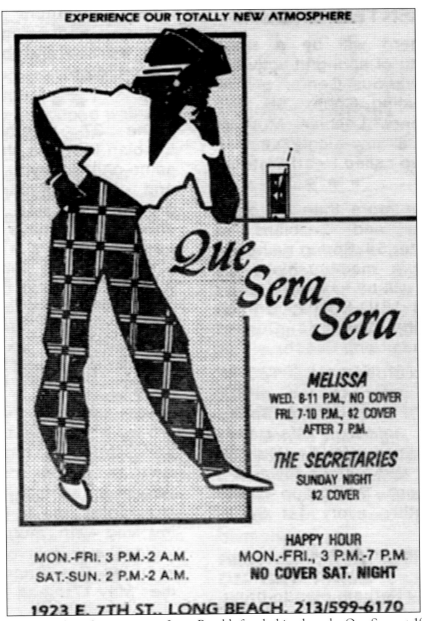

Around the corner from Sojourner was Long Beach's first lesbian bar, the Que Sera, at 1923 Eastt Seventh Street. Originally called the Monarch, the new owner, Ellen Ward, changed the name in 1975. The Que Sera offered music, dancing, and the only live entertainment in town. Musician Melissa Etheridge credits her start at the Que Sera, where she performed Wednesday and Friday nights for several years. Her song "Cherry Avenue," which is the street adjacent to the bar, tells the story of her singing at the Que. Ward later was elected to Signal Hill City Council. She was honored for her support of the lesbian and gay community through the donation of her time, energy, and use of her bar for community fundraisers at the 1985 Lambda Democratic Club Human Rights Banquet, where she received the Lambda Outstanding Woman award. (Historical Society of Long Beach.)

Melissa Etheridge (right) is pictured with Julie Bartolotto, executive director of the Historical Society of Long Beach (HSLB) at the 2013 exhibit Coming Out in Long Beach. From the beginning at HSLB, Bartolotto has been incredibly supportive of preserving Long Beach's feminist and LGBTQ history. Her academic thesis was entitled "An Early History of Women's Studies at California State University, Long Beach: 1968–1976." (Historical Society of Long Beach.)

The Daily Forty-Niner

CALIFORNIA STATE UNIVERSITY, LONG BEACH
VOLUME 27, NUMBER 35

Tuesday, October 21, 1975

A DEPARTMENT OF JOURNALISM LABORATORY NEWSPAPER PUBLISHED DAILY BY THE UNIVERSITY AND THE ASSOCIATED STUDENTS

HEAL! Robin Tyler as Reverend Ripoff heals "rape victim" Vern Padgett after badgering him about his previous sex life. Tyler is part of the feminist comedy team, Harrison and Tyler, who appeared on campus as part of Gay Pride Week. Photo by Tom Kasser

Pickets interrupt Harrison and Tyler at Student Union

By Rebecca Casares
F-N Staff Writer

Pickets interrupted the first event of Gay Pride Week on Monday, Ajay Martin Jr., director of the Student Union, criticized the picketing, which he said was not allowed in the Union.

As the comedy group Harrison and Tyler were performing in the Multi-Purpose room at noon, a group of students assembled at the door. They were shouting and carrying picket signs with such slogans as "Don't be a freak—be a normal Christian," according to Lynn Baker, speaking for the Gay Students' Union.

Baker reported that one of the picketers came inside the auditorium and one of the performers asked him to leave. When he didn't leave, the performer left the stage and escorted him out.

Martin appeared angered at the picketers being in the Union.

"This is a safe house," he said. "Anyone with any belief can have programs in here. Pickets are not allowed."

After the comedy skit, approximately 25 persons attended a reception for Harrison and Tyler held in the Women's Referral Center.

Speakers, plays, poetry, film will highlight Gay Pride Week

By Cathy Franklin
Ass't City Editor

Gay Pride Week will continue for the next four days with speakers and entertainment, then offer a weekend conference and a dance aboard the Queen Mary, according to Mark Andrea, conference chairperson.

"The event has been designed to give recognition to campus gays and to offer education to the university community," he said.

A change in the previously established schedule will bring Jeanne Cordova to the Student Union's Small Auditorium on Tuesday instead of Wednesday. Cordova, human rights editor of the Los Angeles Free Press, is a prominent feminist in Los Angeles.

Christopher Isherwood, who authored the story on which the play and movie "Cabaret" were based, will hold a casual sit-down conference in the Informal Lounge in the Union from 7 to 9 p.m. Tuesday.

"Virgin Bleach," a trilogy of one-act plays will run through Wednesday night in the Small Auditorium.

The play pertains to the gay lifestyle and is designed to raise consciousness, according to Andrea. The first act deals with poetry set in flash scenes, while the second and third plays deal with a female couple and a male couple respectively.

Tuesday's events will open with Dr. James Johnson, a Cal State Long Beach classics professor who will speak on "The Truth About Greek Love," in the Small Auditorium at noon.

On Thursday, New York film critic Vitto Russo will offer "The Celluloid Closet," a montage of stereotyped gay images in film beginning at noon in the Small Auditorium.

Appearing in the evening will be Judy Grahn and Pat Parker, lesbian poets from Oakland, who will read in the Small Auditorium.

On Friday, Rita May Brown, radical lesbian author of "Rubyfruit," "Jungle," and "Songs to a Handsome Woman," will appear on the Speakers' Platform at noon. Brown is also editor of "Quest," a feminist quarterly magazine.

The Gay Students Union West Coast Conference will then run from Friday through Sunday. The program is largely information oriented, although it concludes with "Dance on the Queen" Sunday night.

Some of the topics to be covered during the weekend session include blacks in the gay community, gay liberation in church, gays in business, gay legal counseling and a workshop on grassroots political action.

Folk Life funding is nixed

By Ann Pepper
F-N Staff Writer

The Folk Life Center, a community branch of Cal State Long Beach was turned down by the Long Beach city council last week in its request for $6,000 for an off campus headquarters.

By a vote of 5 to 4, with council members Don Phillips, Ernie Kell, Eunice N. Sato, Wes Carroll Jr. and Russ Rubley voting against the motion, the council rejected the request. But it said it would continue to search for a space for the project.

The center, which is funded by a $15,000 Chancellor's Innovative Grant, is temporarily housed in the Long Beach Library's Periodical Reading Room at 110 Ocean Boulevard.

The center, which is intended to be a vehicle through which various departments of the university can work off campus with the community, needs the building to fulfill its purpose, according to Ben Levine, a spokesperson for the group.

"There are so many skills on campus that can be used by the city. The people on the council who voted against us can't see the dimension. They bewail the fact that the university has no relationships with the city, yet when we try to establish it we are almost entirely rejected. This is a tragedy," Levine said.

"Most organizations in the city are interest groups. Religious, study, art, music, ethnic groups, but there is nothing in the city that includes all kinds of people who can come together for all kinds of activities," Levine added.

Councilman James H. Wilson, who, along with council members Renee Simon, Wallace Edgerton, and Dr. Thomas J. Clark, voted for the project, said he felt the Folk Life Center "falls into the realm of things we want to do." He said the city should fund the cost of a headquarters if it can't provide any city building.

Councilman Kell disagreed. "This money is not free, it's coming from the taxpayers," he said. He said the center should go to the private sector for funding.

Levine can be contacted in the comparative literature department by persons interested in participating in the center.

BOC funds eight-page Monday F-N

A $10,937 budget was approved Monday by the Associated Students Board of Control to fund a full eight-page Monday edition of The Forty-Niner newspaper. The budget awaits A.S. Senate approval.

The budget includes $5,000 in A.S. fees and $5,937 in anticipated revenue (money that is expected through advertisements in the F-N).

Paul Oberjuerge, student editor of The F-N, appeared before the BOC for the third time, the budget being previously rejected, and then postponed.

According to Oberjuerge, "We can expect an eight-page paper this coming Monday if the senate approves the BOC minutes."

In other business the BOC approved a $1,225 budget to fund a Folk Life-Bicentennial Conference to be held on campus on February 28.

The Associated Students of Comparative Literature received approval to fund a
Continued on page 8

Inside The F-N:

A ballet seminar was captured on film here last Saturday.
For Tom Kasser's photo essay on the joys of the dance, see ... Page 5

The 49er football team finds itself back in the midst of the PCAA title race. Tim Burt explains Page 7

A CSULB professor is engaged in making a film on the life and times of Will Rogers Page 8

California State Long Beach was built in 1949 over the sacred Tongva site of Puvunga. Students first celebrated Gay Pride Week in 1975 and were met by protestors yelling "Don't be a freak. Be a normal Christian." By the mid-1980s, the campus opened a Gay & Lesbian Student Union, which offered weekly meetings, social events, and community service. GLSU sponsored the first campus "Coming Out" day. (*Daily 49er*, CSULB.)

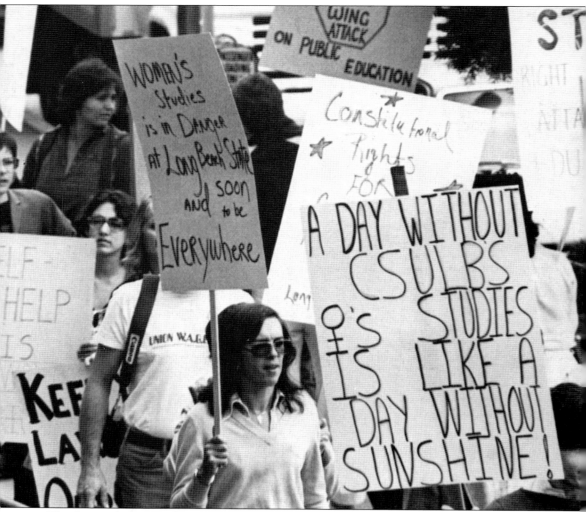

The Center for Women's Studies offered classes in 1972. A group of conservatives belonging to Eagle Forum and Grace Brethren Church placed spies in the classes and scoured the campus Women's Center and Sojourner Bookstore for flyers in search of proof of lesbian activities. They collected titles of the textbooks used in the classes, which they considered pornographic and advocating lesbianism, and took them to the police. They presented their "findings" to the city government to stop the establishment of a Status on Women Commission. They went even higher and contacted three conservative state senators to investigate and mandate the restructuring of the program to include more traditional views of women and to fire several instructors. They alleged the courses were "a front for the training and recruitment of feminists and lesbians." They sued Cal State to close the program but the case was dismissed. This image was published in the CSULB *Beach* in 1983.

In 1982, Betty Willis Brooks (pictured) was targeted for removal from women's studies. For several years, Brooks taught self-defense classes. When she taught Women and Their Bodies, three students complained she was teaching them to perform gynecological self-examination after viewing slides of Brooks's genitalia and then encouraging them to fantasize about being with women. The American Civil Liberties Union (ACLU) fought to have Brooks reinstated. Within three years, Brooks, and all other instructors teaching women's sexuality, health issues, self-examination, or courses on lesbians were pushed out of the women's studies program by the dean. The program director, Dr. Sondra Hale, was fired when she would not go along with the purging of instructors. Hale, Brooks, Denise Wheeler, Diane Wicker, Linda Shaw, and Sheila Kuehl successfully sued the university for discrimination. CSULB now offers a BA in women's, gender, and sexuality studies and includes several courses on lesbianism and queer studies. (Author's collection.)

While ACLU attorney Susan McGreivy was fighting against the purge of lesbianism from Cal State Long Beach, she was also fighting the discharge of 24 of the 68 women assigned to the USS *Norton Sound* (pictured) docked in the Long Beach Naval Shipyard. The women were the first to serve on active duty aboard a ship. Twenty-four were investigated for "unsuitability . . . because of homosexual acts." Eight were officially charged but McGreivy successfully argued their cases. Maryanne Knox (pictured) was released from the Air Force "because I did something different in bed," and demonstrated for USS *Norton Sound* women accused of homosexuality. It took until 2011 for gays and lesbians to be able to serve openly in the US military. (Above, US Navy; below, Los Angeles Times Photographic Archive, UCLA Library Special Collections.)

Numerous resources for LGBTQIA+ students have been added to the campus. The CSULB LGBT Resource Center opened in 1989. In 2007, the first CSULB Lavender Graduation was held. In 2021, the Lesbian, Gay, Bisexual, Transgender, Queer, Intersex, Asexual, Aromantic + Campus Climate Committee (LGBTQIA+ CCC) formed as a subcommittee of the general Campus Climate Committee to "collaborate with all segments of the University to recruit, retain, and promote the success of LGBTQIA+ students, staff, faculty, and administrators." The campus also offers the Rainbow Café, which students can drop in during campus hours. (Both, CSULB.)

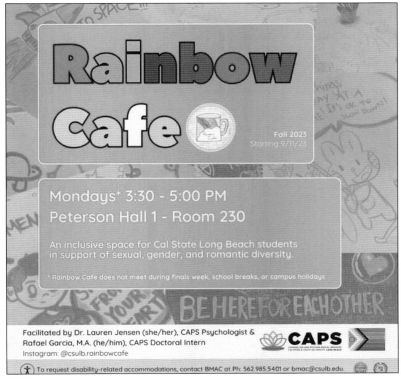

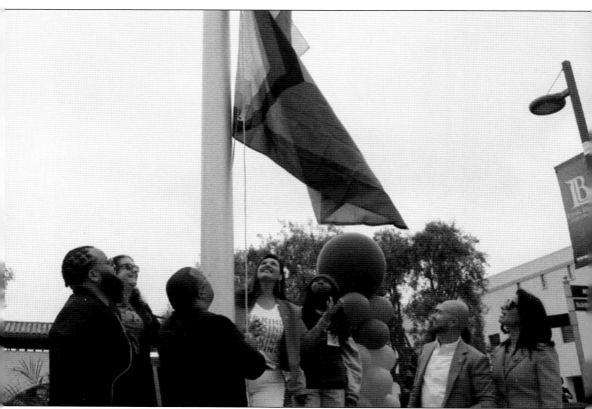

Until the early 1960s community colleges, or "junior" colleges as they were called, were part of the unified school district and were governed by a board of education. State legislation allowed a separate board of trustees to govern. In 1992, the voters of Long Beach, Lakewood, Signal Hill, and Catalina elected the first lesbian trustee, Gerrie Schipske, to the Long Beach Community College District Board of Trustees. On May 20, 2021, the Pride flag was raised for the first time on either of its two campuses in recognition of Harvey Milk Day. The Pride flags at the campuses remained until the end of June, which is the month nationally recognized as Pride Month. LBCC offers resources for LGBTQA students and participates in the annual Pride Parade and Festival. In 2022, Dr. Mike Muñoz, who is openly gay, was selected superintendent-president. (The *Viking News*, Long Beach City College.)

Five

BRIGGS BROUGHT US OUT

Singer Anita Bryant and her husband, Bob Green, helped the Save Our Children campaign repeal the Miami-Dade County, Florida, homosexual rights ordinance. California state senator John Briggs enlisted Bryant's help in his crusade against "homosexual" teachers. Briggs introduced legislation to legalize discrimination against gay teachers. When it failed, he urged voters to place the issue on the ballot as Proposition 6. (Author's collection.)

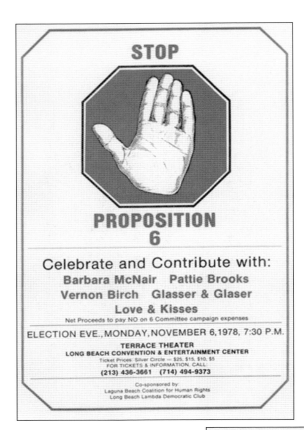

The Briggs Initiative brought out the gay and lesbian community in a way that had not happened before. In 1977, Long Beach Lambda Democratic Club was established for "registering voters, monitoring the Long Beach police department, and supporting an employment act to forbid employers from discrimination against homosexuals." Its first action was to confront chief of police Carl Calkins during a community meeting about the police targeting gay men, as shown in the *Press Telegram* article below. Calkins, new to Long Beach, responded by restructuring the vice squad so that officers were not assigned permanently. Lambda also mobilized voters against Briggs. (Left, ONE Archives at the USC Libraries; below, *Press-Telegram*.)

Gay rights group grills police chief, L.B. city manager

By Brad Altman
Staff Writer

Police occasionally harass homosexuals because some officers believe law enforcement is "a super-macho-type job," Long Beach Police Chief Carl Calkins told a gay rights group.

City Manager John Dever and Personnel Director Barney Walczak joined Calkins in the question-and-answer session before 90 members and guests of the homosexual-oriented Long Beach Lambda Democratic Club this week.

Calkins conceded during questioning by the mostly male audience that police "sometimes get carried away and will try to impose certain personal moral values on

He said homosexuals who believe they have been "falsely arrested or accused have civil recourses. I'm very concerned if officers are filing false reports."

He blamed some vice squad problems on former supervisory decisions that left "some people in a (vice) position for too long. You can get paranoid as a cop also, as well as being paranoid being gay."

Calkins said the Police Department receives "constant complaints concerning homosexual activities in public restrooms."

Dever was asked why the restrooms are so run-down. He explained that the city was "talking about turning the beach operation over to the county the last couple of years."

Lambda annually held a Human Rights Banquet and endorsed candidates for local office. Their political presence resulted in one politician remarking, "There was a time when candidates would not be seen with gays and now, they cannot afford not to be seen." The organization successfully pressed the city council to pass ordinances banning anti-gay employment discrimination ordinance and anti-AIDS discrimination. Lambda would lose four of its presidents to AIDS. (Author's collection.)

A "homosexual guild" of 35 owners and operators of gay bars and restaurants was organized to deal with the Long Beach Police Vice Squad. The members expressed concern about the "selective law enforcement" against homosexuals and the lack of response when patrons were harassed and attacked while standing in line outside the bars. This was published in the *Press-Telegram* on April 24, 1977.

The vice squad estimated 40 gay bars were operating in Long Beach, including Executive Suite, Que Sera, Ripples, The Stallion, Jim's Corral, Lil Lucy's, the Ritz, the Brave Bull, Mineshaft, and Sam's Place. One of the oldest bars, Lil Lucy's, was opened on Broadway and Orange Avenue in 1966 by C.J. Cree, a former circus performer. Sam's Place later became The Brit. (The Brit.)

Lesbian author Marie Cartier reminds in her 2013 book, *Baby, You Are My Religion: Women, Gay Bars, and Theology Before Stonewall*, how gay bars provided "vital sanctuaries" for men and women who were not accepted in heterosexual society. Cartier based her book on hundreds of interviews that disclosed how in the 1940s to 1980s women turned to bars as the only social space where they could be lesbians. (Marie Cartier.)

Club Ripples opened as Long Beach's first dance club in 1972 and was owned by John Garcia and Larry Herbert until 2019 when it closed. In the early 1950s, 5101 East Ocean Boulevard featured the gay bar Oceania. Ownership changed several times, including when actress Shirley Temple's husband, John Agar, bought the building to shut down the gay bar. Ripples was a popular spot but not without controversy. Patrons were frequently harassed by police while standing in line. Some were pelted with stones and eggs by people driving by. The club was firebombed in 1976. For many years, the bar imposed a strict dress code on "butch lesbians" and turned them away at the door. (Both, Club Ripples.)

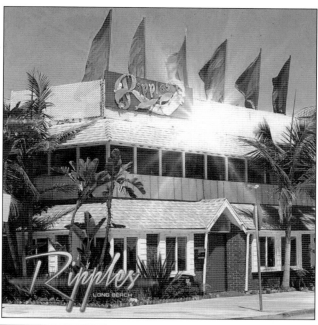

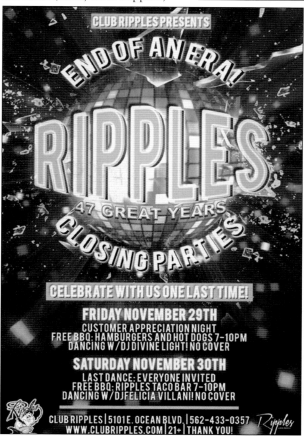

In 1971, the International Imperial Court of Long Beach, Inc., was founded and remains one of the oldest LGBTQ non-profits in the city. It was started in San Francisco in 1965, by José Sarria, the first openly gay candidate for public office in the United States. Its purpose is to raise funds for several LGBTQ-related causes. There are 70 chapters in the United States, Canada, and Mexico. Every chapter in the Imperial Court System is led by an empress, emperor, or emrex. The court raises money through drag shows and other events and has raised more than $1 million for charitable causes in Long Beach. (Left, IICLB; below, JustinRudd.com.)

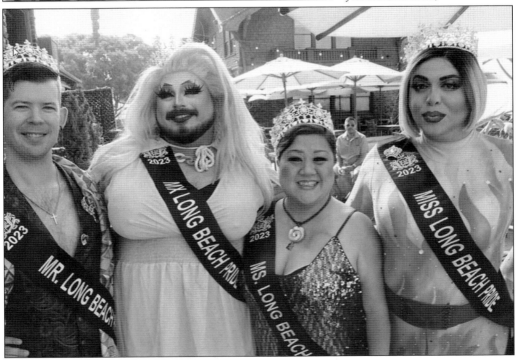

ONE in Long Beach started with informal living room discussions in 1977. Incorporated in 1980, it has been known as the United Community Service Center, the Center/Long Beach, the Long Beach Gay and Lesbian Center, or the Gay and Lesbian Center of Greater Long Beach. Today, it is the LGBTQ Center Long Beach. It was first located at Cherry Avenue and Tenth Street. In 1984, the agency created the first HIV/AIDS case management services in Southern Los Angeles County. Needing more space, the organization purchased a vacant Security Pacific bank building on Fourth Street and Cherry Avenue with the assistance of local realtor Richard Gaylord. The new center opened in 1986. (Both, the LGBTQ Center Long Beach.)

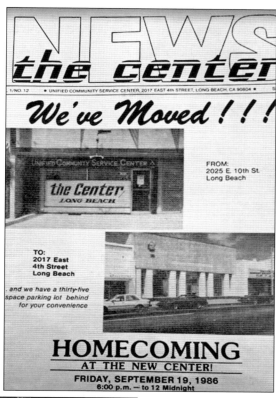

The Center also provides a meeting place for LGBTQ+ organizations. Its lending library features hundreds of volumes of fiction and nonfiction from many decades. Each year, the Center participates in the Long Beach Pride Parade and sponsors the Black and White Masquerade Ball, to raise money for its operations. Below, staff and supporters of the LGBTQ Center Long Beach march in the 2017 Pride Parade and declare their commitment to increasing equity and supporting an intersectional movement to end oppression both within and outside the LGBTQ community. The Mentoring Youth Through Empowerment provides LGBTQ youth and allies with a safe and affirming space in which they can build community, learn essential life skills, and engage in cultural activities with peers and adult mentors. (Above, the LGBTQ Center Long Beach; below, the *Viking News*, Long Beach City College.)

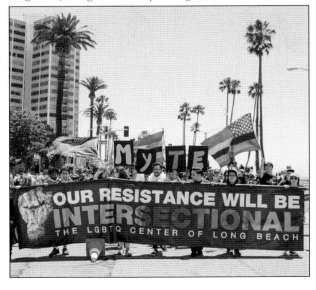

Six
WE LOVE A PARADE

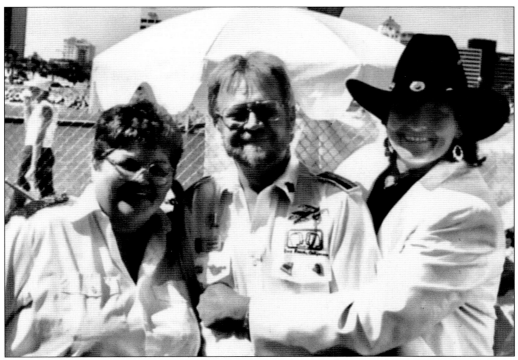

In 1983, Marilyn Barlow, Bob Crow, and Judi Doyle, (pictured) met at the Executive Suite, a gay bar still located on Pacific Coast Highway and Redondo Avenue, to discuss how Long Beach could have a parade and festival like other cities. They started Long Beach Lesbian & Gay Pride, Inc. (LBLGP)—now known as Long Beach Pride. (Long Beach Pride.)

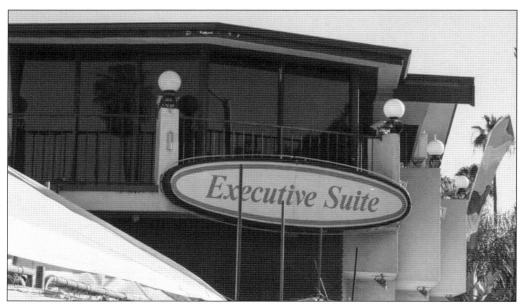

Starting a parade was difficult. Many of the gay bar owners objected to a parade or having it on Broadway. The city required $1 million in liability insurance coverage before issuing a permit. Fred Kovelle, owner of the Executive Suite, let people meet at the bar to discuss the logistics of a parade and festival. Kovelle helped cover costs and provided a float (pictured). The first annual Long Beach Pride Parade lasted 30 minutes and was held on Ocean Boulevard in June 1984, in honor of the Christopher Street parades held in remembrance of the protests at the Stonewall Inn, located on Christopher Street in New York. (Above, CSULB *Daily 49er*; below, ONE Archives of the USC Libraries.)

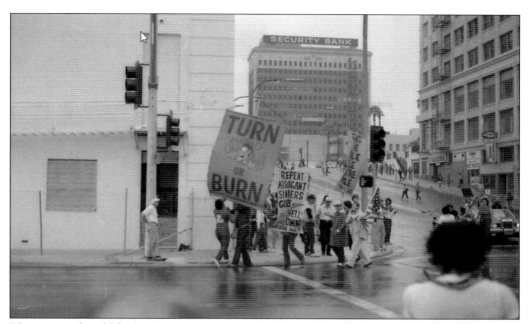

There were a handful of anti-gay protestors waving signs as the parade passed. Based upon the fees levied by the city for barricades and police, LBLGP reported that the parade cost $53 a person as they estimated the parade only drew 300 participants and no more than that as spectators. Almost immediately after the parade, plans were being made for next year's event. (ONE Archives of the USC Libraries.)

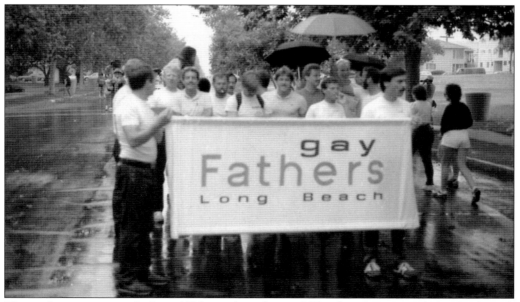

The application was made for a 1985 parade and use of Shoreline Aquatic Park for the festival, and several council members objected. Councilwoman Eunice Sato stated it was "sacrilegious to allow these people to march down our main street on Father's Day." The permit was approved contingent upon what LBLGP considered as "excessive and unreasonable fees and conditions," including a $1 million of insurance coverage. (ONE Archives of the USC Libraries.)

Judi Doyle (left), president of LBLGP, received a death threat before the 1985 parade and was told by Long Beach Police that if she wanted to march in the parade, she should wear a bulletproof vest. No shots were fired. Although the $1 million in insurance was obtained, the ACLU sued the city based on discrimination. The suit was settled, and the city made the insurance requirements the same for all groups wanting a permit to use public streets and parks. The three original founders were honored at the 2013 Pride Parade as grand marshals. Doyle (left) had been a family therapist who became very active in lesbian and gay organizations. Marilyn Barlow (right) managed Sam's Place on Broadway (now the Brit) and then managed the Executive Suite for more than 20 years. Crow met Barlow while working as a bartender at the Executive Suite. (Long Beach Pride.)

The Long Beach Pride Parade and Festival grew, as did the protests by religious groups. The most famous of these is a group led by Bob Engle, known as Bobby Bible. His group consisted of the 13-member Christian Brothers Church. They assembled on the parade route with large hand-painted signs warning participants that "Jesus Saves Sinners from Hell." To counter the parade, the Long Beach First Baptist Church, led by Rev. Mark Chappell, established a "Family Pride Sunday," in 1994. Because of the large LGBTQ+ community, the Westboro Baptist Church of Topeka, Kansas, visited Long Beach several times to picket public places, including Wilson High School. Students and community members came out and the protesters fled. The image below appeared in the *Daily Titan* in 2010. (Right, JustinRudd.com.)

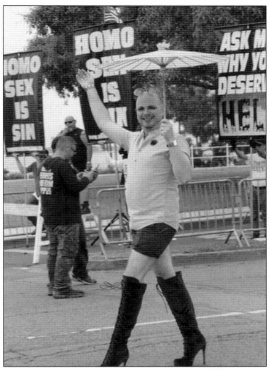

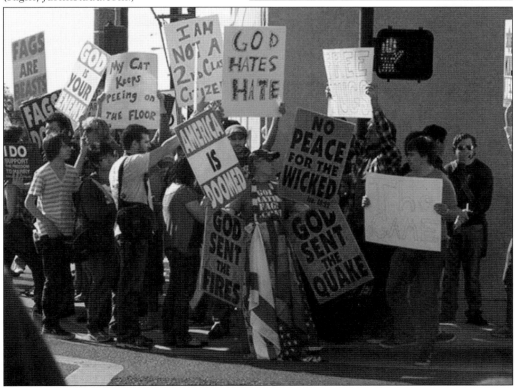

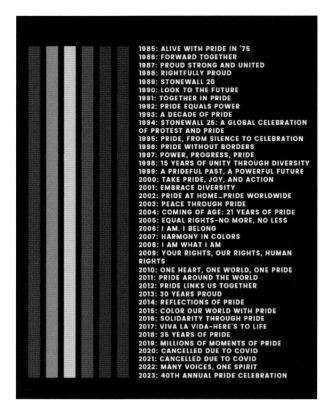

Starting in 1985, each parade and festival was given a specific theme. The initial parade was held in June, and subsequent parades were scheduled for May for 35 years. In 2022, the events were moved to July after two years of cancellations due to COVID-19. In 2023, the event was moved to August by organizers who claimed there would be no conflict with other Southern California events. Beginning in 2024, the parade and festival will be held in May. (Author's collection.)

The Long Beach Pride Parade and Festival featured grand marshals, such as Sheila Kuehl, the first openly lesbian elected to the California Assembly in 1994. She was the grand marshal in 1999. In 2000, she was elected to the California State Senate, and in 2014, Kuehl was the first openly lesbian elected to the Los Angeles County Board of Supervisors. (Author's collection.)

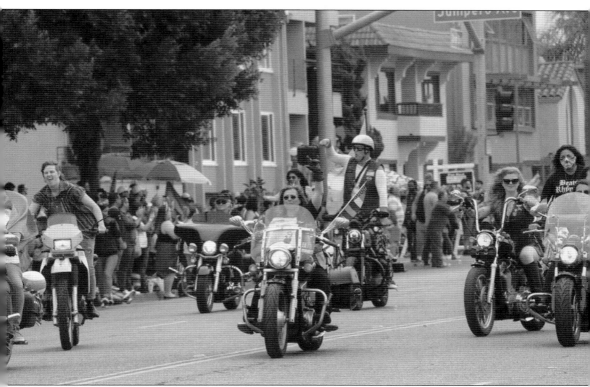

Dykes on Bikes is a nonprofit organization of lesbians who ride motorcycles. Founded in 1976 in San Francisco, the group has 22 chapters across the United States and internationally, including Long Beach. Dykes on Bikes have been leading pride parades since their first appearance when they were known as the San Francisco Women's Motorcycle Contingent. The bikers were put in front of parades because motorcycles did not always run reliably and were faster than the rest of the participants. The Long Beach group is pictured leading the 2018 Long Beach Pride Parade. The group was criticized for adopting the name "dyke," as it was considered disparaging to lesbians. In 2004, the US Patent and Trademark Office (PTO) refused to trademark the name on the basis that under section 2(a) of the Lanham Act, the PTO cannot register any mark that "may disparage a group of people or bring them into contempt or disrepute." They sued, and in 2005, they were given the trademark. (JustinRudd.com.)

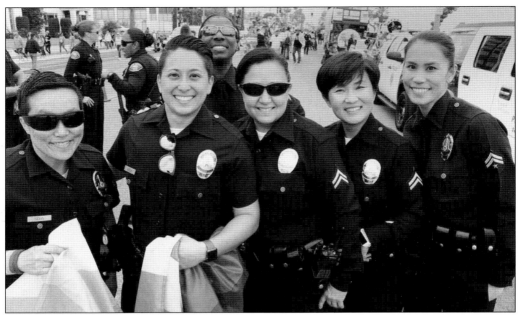

The Long Beach Police Department (LBPD) has participated in the Pride Parade and Festival, for several years, whether by providing city security and traffic control or in later years, walking in the parade. Starting in 1992, the Long Beach Police Department set up a recruitment booth at the Pride Festival. Several female officers pose during the 2018 Long Beach Pride Parade. (JustinRudd.com.)

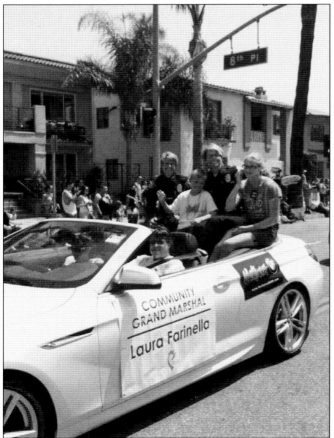

Laura Farinella became LBPD's first openly lesbian deputy chief in 2011. Farinella joined the LBPD in 1990 and held a number of positions including internal affairs. She left Long Beach in 2015 and became the chief of police for the Laguna Beach Police Department, serving there until 2020, when she retired. Farinella is married to another police officer, Dawn Collinske, and they have two children: Emily and Charlie. (LBPD.)

Over the years, the two-day pride festival has featured entertainment by a variety of performers, including RuPaul, Little Richard, Eddie Money, Patti LaBelle, Pat Benatar, The Village People, Sophie B. Hawkins, Indigo Girls, Jennifer Houston, Sheena Easton, Tylor Dayne, and Salt N Pepa. For the first time in 2023, a stage was entirely dedicated to the art of all types of drag. The event was called the Drag Dome, and the idea of Jewels, executive director of entertainment for Hamburger Mary's. Jewels is the first drag queen to receive a key to the city for her charitable work. (Right, Long Beach Pride; below, JustinRudd.com.)

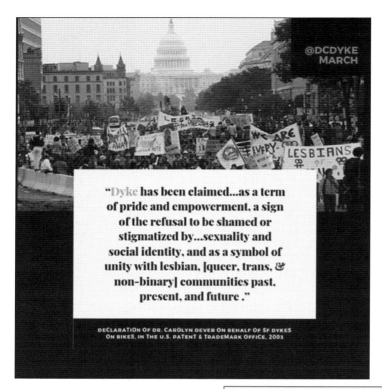

More than 20,000 marched in the first Dyke March held in Washington, DC, in 1993 as part of the March on Washington for Lesbian, Gay and Bi Equal Rights and Liberation. Two months later, a Dyke March was held in San Francisco. The purpose of the marches is to give lesbians visibility and support. (DCDykeMarch.com.)

The Dyke March held in Long Beach in 2013 was the "brainchild" of Artful Thinking Organization (ATO). Robin Tyler, an activist and comedian, led the march of over 400. The Dyke March begins with speeches at Bixby Park (130 Cherry Avenue) followed by a spirited march west along the Broadway corridor to Alamitos Avenue and then back to Bixby Park. The march is held a day or two before the Pride Parade. (JustinRudd.com.)

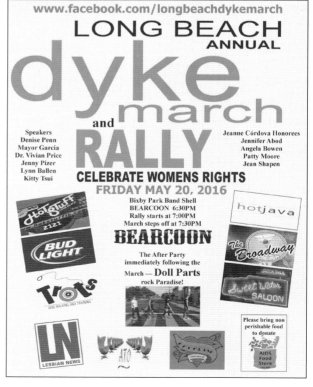

California state senator Pete Knight proposed Proposition 22 in 2000, which defined marriage as "only between a man and a woman." It won with nearly 61 percent of the vote. Eight years later, the California Supreme Court ruled Proposition 22 unconstitutional. However, the same year, 13 million voters on a 52–48 percent vote amended the state constitution to prohibit same-sex marriage by passing Proposition 8. Tom Crowe texted his friends to gather on Broadway to march against Prop 8. More than 3,000 showed up. Proposition 8 was found unconstitutional by a federal judge in 2013. Councilwoman Gerrie Schipske and Vice Mayor Robert Garcia, both openly gay, helped raise the LGBT Pride flag over the Civic Center for the first time. It flew while the US Supreme Court heard gay rights cases. In 2015, same-sex marriage was made legal nationwide in the landmark Supreme Court civil rights case *Obergefell v. Hodges*. (CSULB, *Daily 49er*.)

Long Beach Lesbian and Gay Pride, Inc., has come a long way since its early years in the late 1980s (pictured). The parades and festivals have expanded as has the attendance. In 2020, the board of directors changed its name to Long Beach Pride, and three years later, it marked its 40th year in Long Beach. (Long Beach Pride.)

Pride's 2023–2024 board includes Pres. Tonya Martin; Dr. Cassandra Richards, secretary; Wayne Manous, treasurer and VP festival setup; LaRhonda Slaughter, VP administration; Dwashonique "Shay" Sanford, VP entertainment; Chris Duvali, VP production; Grace Licerio; Elsa Martinez; Denise Newman; and Renea Page. Extended members are Daniel Almazan and Ulysses Brand, and an associate member is Lovette McDonald. (Long Beach Pride.)

Seven

PEOPLE ARE DYING. DOES ANYONE CARE?

> **CENTERS FOR DISEASE CONTROL**
> **MMWR**
> **MORBIDITY AND MORTALITY WEEKLY REPORT**
>
> June 5, 1981 / Vol. 30 / No. 21
> Epidemiologic Notes and Reports
> 249 Dengue Type 4 Infections in U.S. Travelers to the Caribbean
> 250 *Pneumocystis* Pneumonia – Los Angeles
> Current Trends
> 252 Measles – United States, First 20 Weeks
> 253 Risk-Factor-Prevalence Survey – Utah
> 259 Surveillance of Childhood Lead Poisoning – United States
> International Notes
> 261 Quarantine Measures
>
> ## *Pneumocystis* Pneumonia – Los Angeles
>
> In the period October 1980-May 1981, 5 young men, all active homosexuals, were treated for biopsy-confirmed *Pneumocystis carinii* pneumonia at 3 different hospitals in Los Angeles, California. Two of the patients died. All 5 patients had laboratory-confirmed previous or current cytomegalovirus (CMV) infection and candidal mucosal infection. Case reports of these patients follow.
>
> Patient 1: A previously healthy 33-year-old man developed *P. carinii* pneumonia and oral mucosal candidiasis in March 1981 after a 2-month history of fever associated with

The Center for Disease Control issued its *Morbidity and Mortality Weekly Report* (MMWR) stating, "In the period October 1980–May 1981, 5 young men, all active homosexuals, were treated for biopsy-confirmed Pneumocystis carinii pneumonia [PCP] at 3 different hospitals in Los Angeles." PCP was later called "gay men's pneumonia." (CDC.)

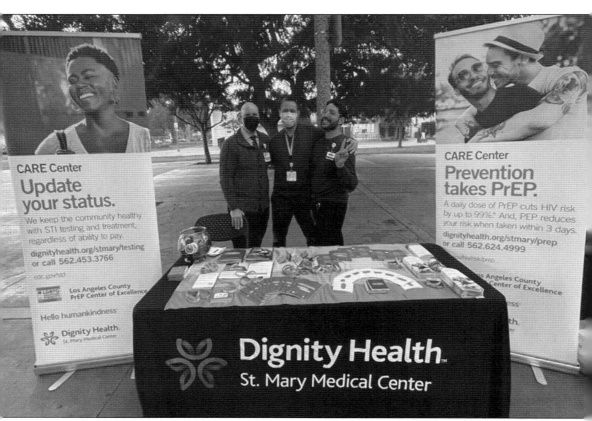

In 1983, the Long Beach Health and Human Service Department began tracking AIDS cases through the AIDS Project coordinated by Ray Kincaide, R.N. Kincaide was honored in 1985 by Lambda Democratic Club for "his commitment to the health services for the gay and lesbian community . . . and being the driving force behind Project AHEAD, which is the major local organization support PWAs—Persons with AIDS. He has been instrumental in bringing the issue of AIDS to the forefront of public consciousness through education of the gay and lesbian community." Persons diagnosed with AIDS had difficulties finding care and medical treatment in Long Beach. St. Mary Medical Center began its CARE program in the 1980s. The program has grown and continues to offer health education, HIV/AIDS care and treatment, and hospital services for people of all ages in Los Angeles County. (City of Long Beach LBCHPC.)

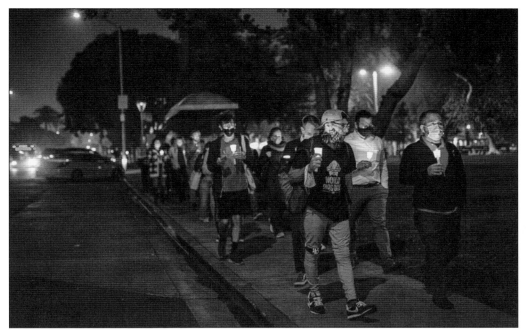

"World AIDS Day" is commemorated annually on December 1 to remember those we have lost. Community members gather at Bixby Park to honor the memory of the patients from the CARE Center who passed during the last year and participate in a candlelight vigil walk to Cherry Beach. CARE belongs to the Long Beach Comprehensive HIV Planning Group (LBCHPG), a group open to all persons affected, afflicted, or working with HIV. The LBCHPC holds quarterly meetings. Drag queens such as the Los Angeles Sisters of Perpetual Indulgence have used their performance talents to raise money for CARE and other AIDS programs. (LBCHPC and JustinRudd.com.)

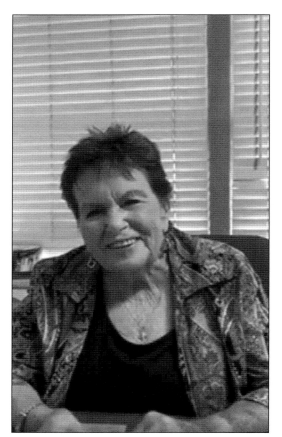

Many lesbians stepped up to help their friends with AIDS. Margo Martinez, a member of Christ Chapel Long Beach, worked with others to address the issue of hunger because many social service agencies were unable or unwilling to help. In November 1985, AIDS Food Store Long Beach was born, with a commitment that no one in the Long Beach area living with HIV/AIDS disabilities would ever be without food, love, and support. In 2017, the store relocated to Willow Street and Atlantic Avenue, serving 250–300 clients a year. Supporters participate in the annual Pride Parade and accept donations as they walk. John Newell has helped run the store for over 18 years. (Left, Christ Chapel; below, JustinRudd.com.)

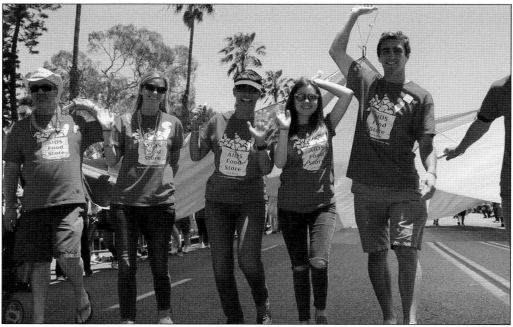

The politics of discrimination hit hard with the spread of HIV and AIDS in the 1980s. Health bulletins to physicians stated, "Since the first AIDS cases were diagnosed in 1979, virtually all cases have occurred in four identified AIDS risk groups: 1) homosexual or bisexual males, 2) IV drug abusers, 3) Haitians recently arrived in the United States, and 4) hemophiliacs." In 1986, the Prevent AIDS Now Initiative Committee (PANIC), working closely with Lyndon LaRouche's national organization, gathered signatures to place a statewide proposition on the ballot to declare AIDS an "infectious, contagious and easily communicable disease" under the state's health law. Among other actions, it would allow the quarantine of those who tested positive and prohibit those with the virus from teaching or working in the food industry. Feminist lesbian activist Ivy Bottini speaks out at a rally. The initiative was defeated by 71 percent to 29. (ONE Archives at the USC Libraries.)

Ellen Ward, Que Sera owner, served on the board of directors of the LGBTQ Center in Long Beach, for many years. When AIDS took the lives of more than one-half of the board, Ward responded and founded AIDS Walk Long Beach and served nine years as executive director. Since its founding in 1988 and the first walk on March 12, 1989, AIDS Walk Long Beach has raised millions of dollars. (Historical Society of Long Beach.)

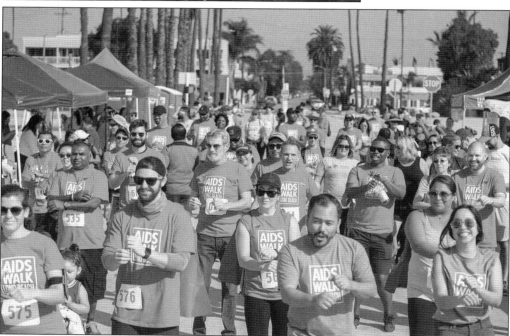

AIDS Walk Long Beach funds critical HIV prevention and support services, including free condoms, HIV and STI testing, food pantry support, case management, PrEp and PEP counseling, medication support, primary medical care, and social and support groups in multiple languages. The walk came back after COVID-19 in 2021 on the walking path along the beach. The walk is 5 kilometers, or 3.1 miles. (AIDS Walk Long Beach.)

The combination of governmental inaction and public apathy moved activist Larry Kramer on March 10, 1987, to challenge people in a meeting at the Lesbian and Gay Community Services Center in Greenwich Village whether they were willing to form a group to bring attention to the AIDS crisis. Their answer resulted in AIDS Coalition to Unleash Power (ACT UP), a political action group that sought to affect change and bring widespread attention to the AIDS crisis; the group adopted "Silence=Death" as its motto. A Long Beach chapter of ACT UP was formed and protested at the Federal building in Los Angeles with other chapters in 1989. The chapter marched in the Long Beach Pride Parade, demanding a governmental response. (ACT UP and ONE Archives at USC Libraries.)

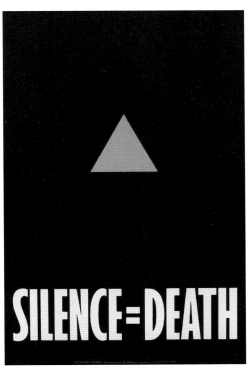

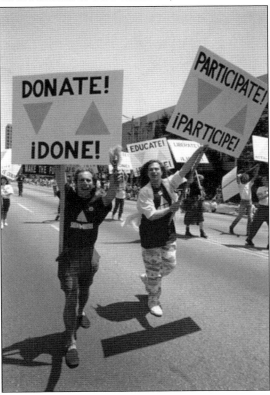

In 1989, the city council voted 7-0 to adopt an ordinance prohibiting discrimination against persons with AIDS in housing, employment, and medical and business services. There were 600 cases of AIDS in Long Beach, the highest in the county. That same year, theatrical students at California State Long Beach performed in *The Normal Heart*, a play by Larry Kramer about the AIDS epidemic. As of 2023, Long Beach continues to have one of the highest number of HIV infections in Southern California. (LBCHPC.)

Out of the Closet Thrift Stores opened in 1990 through AIDS Healthcare Foundation (AHF). The stores use their revenues to provide free HIV testing and AHF Pharmacy services. People can get tested for HIV or fill their prescriptions and shop while they wait. The stores offer finger-prick HIV tests that offer same-day results. The Long Beach store is located at 3500 Pacific Coast Highway, adjacent to the Executive Suite bar. (Out of the Closet Thrift Stores.)

The AIDS Quilt was started by the NAMES Project Foundation to commemorate the thousands dying of AIDS. The quilt was put on display across the country. In 1991, a total of 800 of the 11,425 panels were placed on display aboard the *Queen Mary* in conjunction with AIDS Walk Long Beach. Newspapers reported that as of 1991, there were 117,781 AIDS patients in the United States and that 70,313 had died. The photo above shows a panel made by the NAMES Project Long Beach. Funds were requested from the City of Long Beach through its "cultural arts grant program" to help with the costs of the display. The city refused the request for $8,600. (National AIDS Memorial and City of Long Beach.)

```
Long Beach AIDS Network
                                   $8,600                NOT FUNDED

Project description: Display of the National AIDS Quilt for 3-days
     at the Queen Mary; 100 presentations of quilt to 7th grade
     health classes; poster contest for school children on AIDS
     awareness.  Top posters will be displayed along side the
     National Quilt on the Queen Mary.
```

DOUGLAS S. DRUMMOND

In 1993, the Long Beach City Council unanimously voted to censure Third District council member and former Long Beach police officer Doug Drummond for making offensive remarks while speaking to the conservative Eagle Forum, on the issue of "family values." Drummond was taped and told the group that he was not concerned about gays and lesbians, because "thousands are dying of AIDS, and gays and lesbians do not reproduce." He also told the group he supported the Cuban government's policy of quarantining those with AIDS and that he found it "pitiful that gays and lesbians are allowed to adopt children." Drummond previously led the opposition to providing family health benefits to city employees in gay relationships. The council initially voted five to three against the domestic partner benefits. Drummond rode in the 23rd Annual Long Beach Pride Parade in 2006 when he ran for mayor. He was later appointed to the city's harbor commission. (City of Long Beach.)

Eight
LGBTQA Politics

In 1982, Richard "Dick" Gaylord was the first gay candidate for city council. Gaylord, a successful realtor, became the president of both the California Association of Realtors and the National Association of Realtors. He was appointed to several city commissions and the Long Beach City College Personnel Commission. He ran unsuccessfully for Long Beach City College Board of Trustees in 2022. (The *Viking News*, Long Beach City College.)

Two openly gay men ran for city council in 1999. Dan Baker (pictured left on left), a US Customs agent, and Robert Fox, (pictured below) a small business owner. Baker won and ran for mayor in 2002. He remained on the city council and resigned from the city council in 2006 because of problems with alleged real estate transactions for which he was later cleared. Fox came to Long Beach in 1984 and worked as a chef in the gay and lesbian bar and restaurant Details. Over the years, he invested in real estate and formed and served on a number of community organizations including the Alamitos Beach Neighborhood Association. Fox ran again for city council in 2022. (Left, author's collection; below, Robert Fox.)

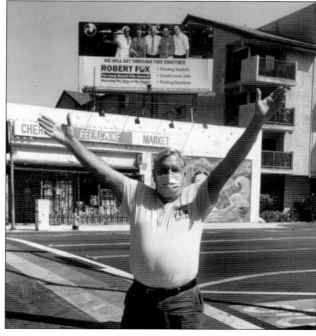

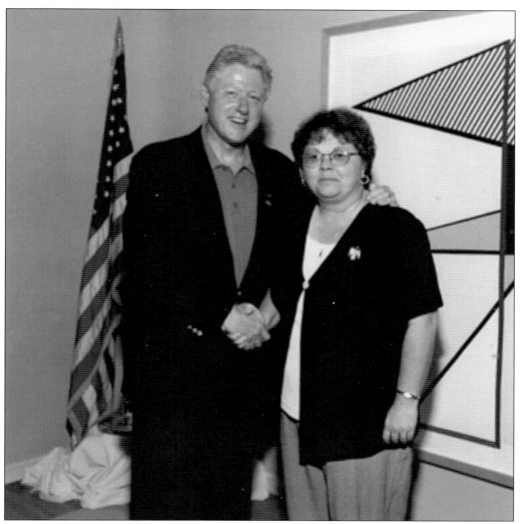

Long Beach–born Gerrie Schipske is the first and only lesbian in Long Beach to win public office. In 1992, she won a seat on the four-city Long Beach Community College Board of Trustees, defeating a longtime incumbent. She worked to bring district elections and diversity to the college board. In 1996, she won the Democratic primary for Assembly. She survived a last-minute mailer sent by her opponent accusing Schipske of being "committed to a radical gay rights agenda" because she was supported by Assemblywoman Sheila Kuehl, who was one of two lesbian state legislators. Schipske lost the general election by one percent of the 132,000 votes cast. In 2000, Schipske won the Democratic primary for the 46th Congressional District, defeating five other candidates. Her campaign asked local grocery stores to remove flyers warning voters that "Schipske is a lesbian" that were stuffed between boxes of baby diapers. Pres. Bill Clinton campaigned for Schipske. She lost the general election by less than one percent of the 169,000 votes cast. Schipske won a seat on the city council in 2006 and was reelected in 2010. (Author's collection.)

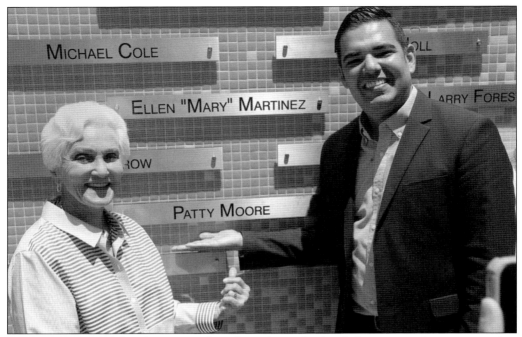

Patty Moore (pictured with Mayor Robert Garcia) was the first lesbian to run for city council in 1994. Patty and her partner, Jean Shapen, owned Details on Broadway. Moore was honored by the City of Long Beach and her name was placed on the Harvey Milk Promenade and Equality Plaza. In 1996, attorney Rick Zbur was the first gay man to run for US Congress in Long Beach. He later moved from Long Beach and was elected to the state assembly in 2022. (JustinRudd.com.)

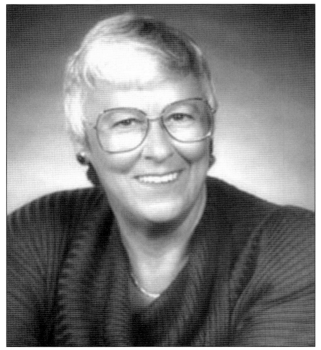

The city council finally approved domestic partnerships in 1997 through the efforts of the Coalition for Domestic Partnerships headed by Connie Hamilton (pictured). The city council had taken up the issue of domestic partnerships in 1996. Councilman Jerry Schultz, a Los Angeles County deputy sheriff, objected on the basis the city would also have to recognize relationships between "a man and a female sheep or a foot stool." (City of Long Beach.)

Attorney Stephanie Loftin (pictured on right) ran for city council in 2006 against four other opponents, including community activist and fellow gay, Justin Rudd. Loftin defeated Rudd and two others but lost in the general election. Loftin manages Long Beach Law with her partner, Reba Birmingham (pictured on the left), who served as president of the Long Beach Bar Association in 2022. Birmingham won a 2008 groundbreaking case, *Ellis v. Arriaga*, establishing California's putative spouse rights for registered domestic partners. Loftin also won a groundbreaking case in 2016 when she cocounseled the case *People v. Rory Moroney*, which resulted in the judge dismissing charges against the defendant. The judge also issued a blistering statement against the Long Beach Police Department for conducting sting operations against gay men in public restrooms, and ruled that the tactics were discriminatory. Loftin is pictured with Rory Moroney. (Above, JustinRudd.com; right, *Q Voice News*.)

Robert Julio Garcia immigrated to California from Peru with his mother when he was five. He later attended California State University at Long Beach serving as student body president and head of the Young Republicans. Garcia earned a doctorate in education and taught briefly at CSULB, USC, and LBCC. He was elected to the city council in 2009 to fill a vacant seat. Garcia won a four-year term in 2010. In 2014, he became the first gay, Latino mayor of Long Beach and won reelection in 2018. He married his partner, Matthew Mendez, a professor at CSULB. In 2022, Garcia was elected as a Democrat to the US Congress, becoming the first LGBTQ Latino to serve. (Both, JustinRudd.com.)

One of the requirements of the Human Rights Campaign's Municipal Equality Index Scorecard is that a city has an LGBTQ+ liaison in the city executive's office. Tim Patton served in that position during Mayor Garcia's two terms. Patton served in city hall since 1992 working for several members of the city council. He also served on the staff of Assemblywoman Bonnie Lowenthal. (JustinRudd.com.)

The LGBTQ Center Long Beach raises funds with its annual event It's a Drag to Give. Prominent members of Long Beach are invited to try out performing in drag. Tim Patton performed in 2019, to rave reviews as Lola LoBeach dressed as Mrs. Santa Claus. The event is held at the Long Beach Convention Center. (Courtesy of Tim Patton.)

LONG BEACH, CALIFORNIA 1/2
2022 MUNICIPAL EQUALITY INDEX SCORECARD

I. Non-Discrimination Laws**

This category evaluates whether discrimination on the basis of sexual orientation and gender identity is prohibited by the city, county, or state in areas of employment, housing, and public accommodations.

	STATE	COUNTY	MUNICIPAL	AVAILABLE
Employment	5	0	4	5
Housing	5	0	0	5
Public Accommodations	5	0	0	5

SCORE: 30 out of 30

FLEX Single-Occupancy All-Gender Facilities	+2	+0	+0	+2
FLEX Protects Youth from Conversion Therapy	+2	+0	+0	+2

II. Municipality as Employer

By offering equivalent benefits and protections to LGBTQ+ employees, awarding contracts to fair-minded businesses, and taking steps to ensure an inclusive workplace, municipalities commit themselves to treating LGBTQ+ employees equally.

	COUNTY	MUNICIPAL	AVAILABLE
Non-Discrimination in City Employment		7	7
Transgender-Inclusive Healthcare Benefits		6	6
City Contractor Non-Discrimination Ordinance		3	3
Inclusive Workplace		2	2

SCORE: 28 out of 28

FLEX City Employee Domestic Partner Benefits		+1	+1

III. Municipal Services

This section assesses the efforts of the city to ensure LGBTQ+ residents are included in city services and programs.

	COUNTY	MUNICIPAL	AVAILABLE
Human Rights Commission	0	5	5
NDO Enforcement by Human Rights Commission	0	2	2
LGBTQ+ Liaison in City Executive's Office		5	5

SCORE: 12 out of 12

FLEX Youth Bullying Prevention Policy for City Services	+0	+0	+1 +1
FLEX City Provides Services to LGBTQ+ Youth		+0	+2
FLEX City Provides Services to LGBTQ+ People Experiencing Homelessness		+0	+2
FLEX City Provides Services to LGBTQ+ Older Adults		+0	+2
FLEX City Provides Services to People Living with HIV or AIDS		+2	+2
FLEX City Provides Services to the Transgender Community		+2	+2

The Human Rights Campaign's Municipal Equality Index Scorecard is compiled annually based on information submitted by cities. The MEI outlines standards for credit in several categories, with a total of 100 standard points and 22 flex points. Cities must provide documentation of their accomplishments. In each of the years 2012–2022, the City of Long Beach scored 100 points. The

LONG BEACH, CALIFORNIA 2/2
2022 MUNICIPAL EQUALITY INDEX SCORECARD

IV. Law Enforcement

MUNICIPAL | AVAILABLE

Fair enforcement of the law includes responsible reporting of hate crimes and engaging with the LGBTQ+ community in a thoughtful and respectful way.

	Municipal	Available
LGBTQ+ Liaison/Task Force in Police Department	10	10
Reported 2020 Hate Crimes Statistics to the FBI	12	12
SCORE	**22 out of 22**	

V. Leadership on LGBTQ+ Equality

MUNICIPAL | AVAILABLE

This category measures the city leadership's commitment to fully include the LGBTQ+ community and to advocate for full equality.

	Municipal	Available
Leadership's Public Position on LGBTQ+ Equality	5	5
Leadership's Pro-Equality Legislative or Policy Efforts	3	3
SCORE	**8 out of 8**	
FLEX Openly LGBTQ+ Elected or Appointed Leaders	+2	+2
FLEX City Tests Limits of Restrictive State Law	+0	+3

TOTAL SCORE 100 + TOTAL FLEX SCORE 11 = Final Score 100

CANNOT EXCEED 100

** On June 15, 2020, the U.S. Supreme Court ruled in *Bostock v. Clayton County, Georgia* that sexual orientation and gender identity discrimination are prohibited under federal sex-based employment protections. Nevertheless, it is imperative that localities continue enacting explicitly LGBTQ+-inclusive comprehensive non-discrimination laws since it will likely take additional litigation for Bostock to be fully applied to all sex-based protections under existing federal civil rights law. Moreover, federal law currently lacks sex-based protections in numerous key areas of life, including public spaces and services. Lastly, there are many invaluable benefits to localizing inclusive protections even when they exist on higher levels of government. **For these reasons, the MEI will continue to only award credit in Part I for state, county, or municipal non-discrimination laws that expressly include sexual orientation and gender identity.**

PTS FOR SEXUAL ORIENTATION PTS FOR GENDER IDENTITY FLEX PTS for criteria not accessible to all cities at this time.

FOR MORE INFORMATION ABOUT CITY SELECTION, CRITERIA OR THE MEI SCORING SYSTEM, PLEASE VISIT HRC.ORG/MEI
All cities rated were provided their scorecard in advance of publication and given the opportunity to submit revisions. For feedback regarding a particular city's scorecard, please email mei@hrc.org.

city could have received additional Flex points if it provided a youth bullying-prevention policy for city services, services to LGBTQ+ youth, services to LGBTQ+ people experiencing homelessness, and services to LGBTQ+ older adults. (Human Rights Campaign.)

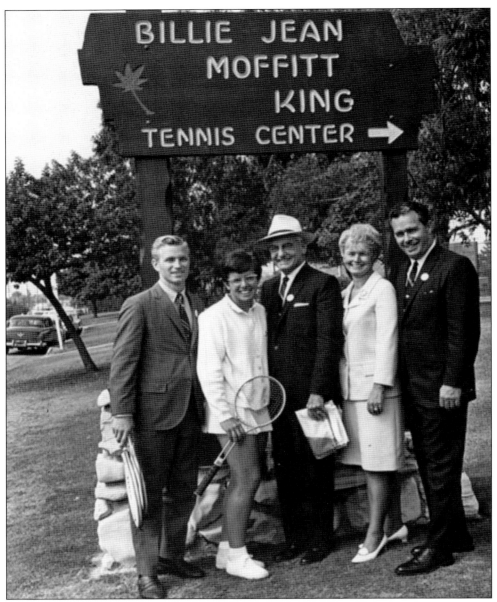

In 1968, the City of Long Beach dedicated the Billie Jean Moffitt King Tennis Center at Tenth Street and Park Avenue in honor of its hometown Wimbledon tennis star. King was born in Long Beach on November 22, 1943. She lived in the Wrigley neighborhood on West Thirty-Sixth Street with her brother Randy and her parents, Bill and Betty Moffitt. Her father was a firefighter, her mother was a homemaker, and her brother went on to pitch for Major League Baseball. Billie Jean attended public schools, graduating from Polytechnic High School in 1961. She began playing tennis in the fifth grade, with lessons from the city's recreation department. At the age of 17, Billie Jean and her doubles partner Karen Hantze won the Wimbledon Ladies Doubles Championship, the youngest pair ever. Between 1961 and 1979, Billie Jean won a record twenty Wimbledon titles, thirteen US titles (including four singles), four French titles (one singles), and two Australian titles (one singles) for a total of 39 Grand Slam titles. (City of Long Beach.)

"Ever since that day when I was 11 years old, and I wasn't allowed in a photo because I wasn't wearing a tennis skirt, I knew that I wanted to change the sport. I wanted to use sports for social change."

– Billie Jean King

By 1966, Billie Jean Moffitt King ranked No. 1 in the world in women's tennis. She held the ranking in 1967, 1968, 1971, 1972, and 1974. She recalls when she was 11, competing at the Los Angeles Tennis Club, being barred from a group photograph because she wore tennis shorts her mother made instead of a white tennis skirt. King has often remarked that the event sparked a sense of injustice and her activism to change the sport. Artist Christina Tarkoff acknowledges that moment in this painting of the tennis superstar. In 1965, Billie Jean married Larry King, a law student who encouraged her to pursue a tennis career. In the early 1970s, Billie Jean realized she was attracted to women and began an affair with her assistant, Marilyn Barnett. The affair ended badly, with Barnett outing Billie Jean and Billie Jean losing more than $500,000 in commercial endorsements. It would take until she was 51 for Billie Jean to tell her mother she was a lesbian. (Courtesy of Christina Tarkoff.)

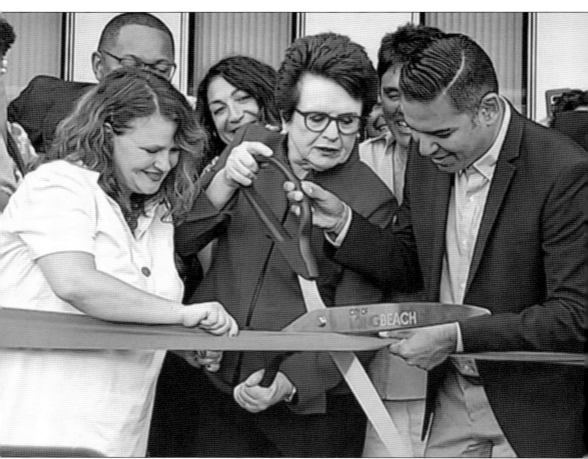

Billie Jean King always talks glowingly about her hometown, so it was natural that Councilwoman Jeannine Pearce (on left) would ask the city council to name the new main library after the hometown tennis star. Pearce told the council, "A library has the power to change lives through books, media, and resource centers. Naming the library after a woman who has spearheaded change for people across the world, a woman who credits Long Beach for her success, is a historic moment and one which I cannot wait to celebrate with all the residents of the city." On Saturday, September 21, 2019, the City of Long Beach celebrated the grand opening of the new Billie Jean King Main Library. The new 92,500-square-foot building is a LEED Gold-certified building of glass and wood and includes space for about 300,000 books as well as study rooms, meeting rooms, a special collections area, an extensive children's area with a storytelling space, an art studio, and more. (Long Beach Public Library.)

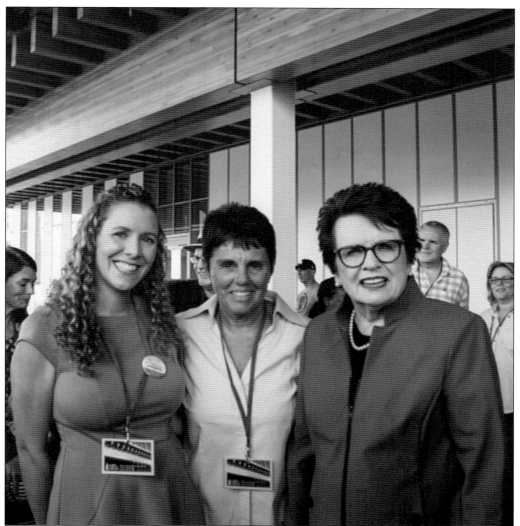

Billie Jean and her life partner, Ilana Kloss, are pictured with the Long Beach Library Foundation executive director, Kate Azar (on left), at the opening of the library named in honor of King. Kloss and King pledged a financial commitment to the Long Beach Public Library Foundation's New Main Campaign. As Billie Jean writes in the foreword of this book about her struggle with being lesbian, she and fellow tennis player Ilana Kloss were in a relationship for 40 years before they married in 2018 at the urging of longtime friend Elton John. She kept the marriage a secret until her memoir entitled *All In* was published in 2021. King says she felt "very married to Ilana" for years before the ceremony but realized being legally married would show her commitment. (Long Beach Public Library.)

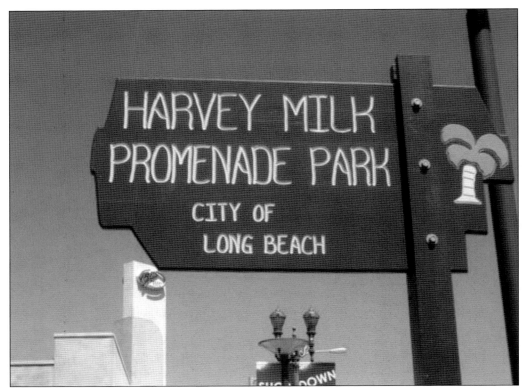

The Harvey Milk Promenade Park and Equality Plaza at the Promenade and Third Street was the first park in Long Beach named after an openly gay person and the first park in the nation named after slain civil rights leader Harvey Milk. The park and plaza beautified an empty paved area at the end of a pedestrian promenade between a busy street and a tall parking structure and provided open space where people could meet. The plaza also features a concrete replica of the soapbox on which Harvey Milk stood in San Francisco speaking before crowds. (Both, LBReport.com.)

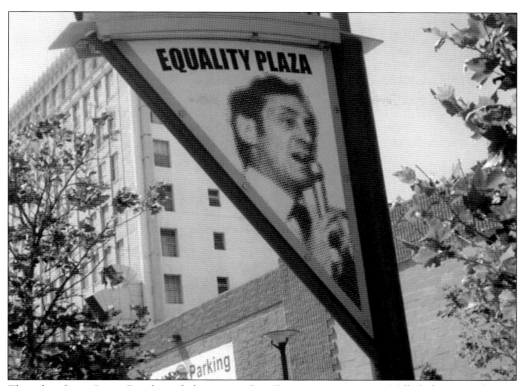

The idea for a Long Beach park honoring San Francisco supervisor Milk belongs to former Councilman Robert Garcia. The concept of an area honoring Long Beach area LGBT pioneers was proposed by former Long Beach councilwoman Gerrie Schipske after a number of area residents voiced the view that Long Beach's first park named for an openly gay person ought to recognize a Long Beach individual (several suggested Poly High graduate and tennis star Billie Jean King). The Equality Plaza was added in 2013 and features the names of those who have worked on behalf of the LGBTQA community. (Above, LBReport.com; below, City of Long Beach.)

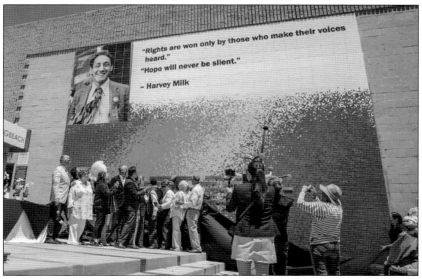

In June 2020, a group of gay Long Beach lifeguards painted the lifeguard station located at the beach near Shoreline Way and Twelfth Place in rainbow colors to commemorate Pride Month. It was the first lifeguard station in the city to feature rainbow colors. At midnight on March 22, 2021, the tower was set on fire and burned to the ground. The fire department classified the fire as "arson." The mayor's office issued a statement calling the fire "an act of hate." The city replaced the station and lifeguards painted it in rainbow colors. The city unveiled the new tower on June 21, 2021. (City of Long Beach.)

Nine
So Many Rainbow Heroes

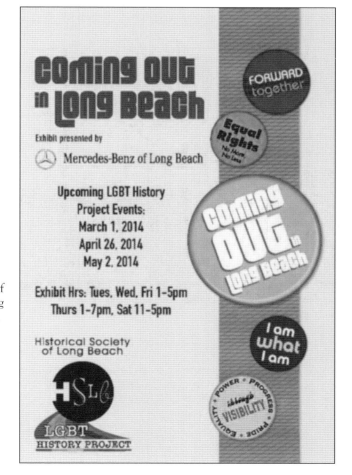

Kudos to the Historical Society of Long Beach for hosting The Long Beach LGBT History Project and the Coming Out in Long Beach exhibition. This project collects artifacts, memorabilia, and personal histories of LGBT life in greater Long Beach over the decades to create an exhibition in HSLB's main gallery, as well as public programs and a feature documentary. (Historical Society of Long Beach.)

There are not enough words to describe Justin Rudd and his numerous contributions to Long Beach. He is considered to be the city's most influential and powerful community activist. A native of Ozark, Alabama, Rudd moved to North Hollywood in 1995. Since arriving in Long Beach in 1997, he has dedicated his life to the good of the city, running more than 60 annual events. In 2001, he organized his nonprofit organization Community Action Team (CAT) and raises money and collects goods for breast cancer, HIV/AIDS and homeless programs, and Long Beach public libraries. For many years, he has traveled to rural Kenya in Africa to raise money for AIDS orphans. He met his partner, Ralph Millero (seated left below), a movie studio executive, in 2003. Together, they share a love of dogs and established the first beach for dogs in honor of their dog, "Rosie." (Both, JustinRudd.com.)

Vanessa Romain (left) and Marsha Naify are powerful behind-the-scenes lesbians who have participated from the earliest days, in assuring Long Beach had a pride parade and places where gays and lesbians could meet socially. Romain worked with Long Beach Pride to provide the needed security and logistics. A social worker by profession, she advocated for HIV/AIDS medical treatment programs. Later, she worked as a constituent representative of lesbian and gay issues, senior issues and women's issues, and veterans for Congressman Alan Lowenthal. Marsha Naify came to Long Beach in the 1970s and, in the 1990s, opened the Community Coffee House/Hot Java as a point location in what has become Long Beach's Gay Corridor. Naify led Long Beach Lambda Democratic Club from 2001 to 2004, raising the largest amount of funds in its history. In 2012, she became cochair of the HSLB's LGBT History Project Steering Committee and helped fund its Coming Out exhibit. (JustinRudd.com.)

When math professor David Newell headed Lambda Democratic Club in 1990, he advocated for a high school counseling program for gay teenagers. Newell, called a "gentle giant" for his six-foot-seven height, at one point remarked. "I am proud to say I was part of the transition of the city of Long Beach, being known as 'Iowa by the Sea' when I moved there, to the progressive and diverse city it is today." (Harvey Milk Promenade and Equality Plaza.)

Newell's efforts to start a counseling program were met with strong opposition, with one LBUSD Board of Education member referring to the proposal as a "project of depravity and filth," and "a recruiting ground for homosexuals." Newell died in 2015 before the State of California required all public schools to provide support services for LGBTQ+ youth. (LBUSD.)

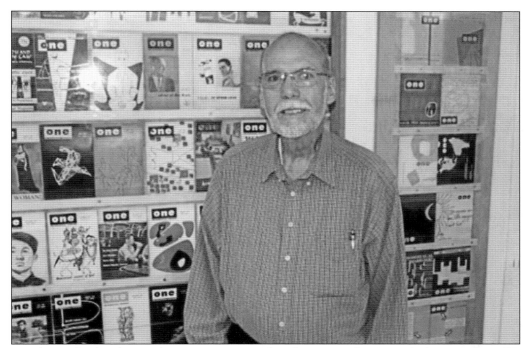

David Hensley has been a longtime Long Beach volunteer at the ONE Archives at the USC Libraries, sometimes working six hours a day. He has organized and archived documents from various groups, including the LGBTQ Center Long Beach. Since 2003, Hensley helped preserve more than two million items related to the LGBTQ community. He was honored in 2015 at the Harvey Milk Promenade and Equality Plaza. (ONE Archives at the USC Libraries.)

Kathie Jean Shafer Harris was raised in Long Beach and became known as "one of the savviest gay organizers in the country." Coming out in the late 1970s, she divorced, moved to San Francisco, and spent decades on the front lines of Democratic and LGBT politics. Harris once served as vice president of Long Beach Lambda Democratic Club. Her name was added to the Harvey Milk Promenade and Equality Plaza in 2013. (California Democratic Party.)

Denise Penn (pictured in center), openly bisexual and partner of Jean Harris, organized Long Beach's first Dyke March in 2013. A social worker and therapist in LGBTQ mental health programs, Penn is also an "advocacy journalist," writing and editing for LGBT and alternative publications as a news reporter, columnist, and editor. Penn's name was added to the Harvey Milk Promenade and Equality Plaza in 2017. (Harvey Milk Promenade and Equality Plaza.)

Pat Lamis's name was added to the Harvey Milk Promenade and Equality Plaza in 2022 in recognition of her community work with LGBTQ seniors. In 1990, Lamis, her partner, Heather Hamm, and Hamm's 16-year-old daughter opened Condom Wrap, a store offering more than 200 types of condoms to foster safe sex education during the AIDS epidemic. (Harvey Milk Promenade and Equality Plaza.)

Ron Sylvester (right) served as president of the LGBTQ Center Long Beach from 2009 to 2016 during difficult financial times and is credited for stabilizing and expanding the Center. Sylvester is president of RS/tv, Inc. and produces online content for IMDb at events such as the Emmy Awards and Golden Globe Awards. Sylvester's name was added to the Harvey Milk Promenade and Equality Plaza in 2017. Sylvester also served on the 2022 Harvey Milk Park Equity Plaza Selection Committee, which chose Brad Duerre (left) and Brad Miyasato (center) to have their names added to the wall to honor the more than 30 years they have volunteered on behalf of the LGBTQ community with AIDS Project Los Angeles, AIDS Food Store (AFS), Human Rights Campaign (HRC), Out and About, and the Shoreline Frontrunners of Long Beach. Frontrunners is an LGBTQ+-oriented running and walking club formed in 1984 as part of the International Frontrunners clubs around the world. (JustinRudd.com.)

Ellen "Mary" Martinez is pictured to the right of her 18-year partner, Vanessa Romain. Together, they worked on many lesbian and gay issues. Martinez was one of the first vice presidents of Lesbian and Gay Pride, Inc., and volunteered with the organization for 25 years. Martinez was among the first to be honored at the Harvey Milk Promenade and Equality Plaza in 2013 as well as Frank Rubio and Ray Lowen. Drag queen Frank Rubio served as president of Lesbian and Gay Pride and vice president of Long Beach Pride production for over 21 years and worked to improve the logistics of the event. Those lucky to know Ray Lowen may have been given one of his rocks painted with a red heart on one side and the recipient's name and a wise saying on the other. Lowen was an artist who used his skills to raise money for The Center and for AIDS research. He helped start a gay discussion group in the early 1970s that became a "hotline." (Historical Society of Long Beach.)

Most people only know a fraction of the work Jack Castiglione (right) has done since arriving in Long Beach in the mid-1970s. Castiglione focused on civil rights issues and LGBTQ rights. He assisted persons with AIDS, fought to stop anti-gay violence, and held the Long Beach Police Department accountable. In the early 1980s, he started a hate crimes hotline out of his house, which forced the Long Beach Police to take hate crimes reports. In 2022, his name was added to the Harvey Milk Promenade and Equality Plaza with several others, including Tonya Martin (below), historian for Long Beach Pride and outreach assistant for the first openly gay state insurance commissioner, Ricardo Lara (below right). Martin became the 2023 president of Long Beach Pride. (Right, Harvey Milk Promenade and Equality Plaza; below, JustinRudd.com.)

Back in 1993, Robert (Dagoberto) Cano started the Long Beach QFilms Festival at CSULB. He got the idea of showing LGBT films after attending a film festival in Washington, DC, during the March on Washington for Lesbian, Gay and Bi Equal Rights and Liberation. In between organizing the films for the Festival, Cano volunteered at the LGBTQ Center Long Beach and helped comfort friends who were hospitalized at St. Mary Medical Center with AIDS. The festival was moved to the historic Art Theatre located at 2025 East Fourth Street, next door to the LGBTQ Center Long Beach. To date, more than 500 films from 50 countries have been shown. (Left, JustinRudd.com; below, QFilms.)

In 2008, Pat Crosby, who is pictured, was married to Ellen Ward, her partner of 18 years. Crosby served as president of Long Beach Lesbian and Gay Pride. Her name was added to the Harvey Milk Promenade and Equality Plaza in 2017 along with Paul Self, an early president of Long Beach Lambda Democratic Club. (Long Beach Pride.)

A serious accident and surgery paralyzed Angela Madsen. Her physical problems did not stop her from founding the California Adaptive Rowing Program. She won four gold medals in rowing at the world championships and a bronze medal at the Paralympic Games. She married her partner Debra in 2013. Unfortunately, in 2020, Madsen lost her life while attempting to row solo from California to Hawaii. (JustinRudd.com.)

In 2014, two gay men were honored posthumously at the Harvey Milk Promenade and Equality Plaza. Carlos De Avila (pictured), the self-proclaimed "Fabulous Fag on Funky Fourth Street," was a professional photographer and artist with a studio space on Fourth Street near Junipero Avenue, a cofounder of the LGBTQ Center Long Beach, and helped organize Lambda Democratic Club. Donald L. Snow served as president of Lambda Democratic Club, also helped establish the LGBTQ Center Long Beach, and helped obtain direct financial assistance for people with AIDS. Snow died in 1993 at the age of 39 from AIDS and contributed a significant endowment to the Lesbian and Gay Lawyers Association of Los Angeles (LGLALA), which funds an annual scholarship for LGBT students. Ernie Villa was honored for his work on historical preservation of the Willmore District and his involvement in HIV/AIDS activism. (Fourth Street Business Association.)

Ernie Villa was honored for his work on historical preservation of the Willmore District and his involvement in HIV/AIDS activism. (Harvey Milk Promenade and Equality Plaza.)

Rev. Michael Cole was honored at the Harvey Milk Promenade and Equality Plaza for starting Christ Chapel Church in 1981 and the AIDS Food Store. Cole moved to Long Beach in 1974 and began a successful drag performance career as Honey Carolina. After hearing Troy Perry preach at the Metropolitan Community Church, Cole decided to dedicate his life to God and gave up drag performance. (lgbtqreligiousarchives.org.)

Raul Anorve is pictured left with Mayor Robert Garcia on the day he was inducted into the Harvey Milk Promenade and Equality Plaza in 2018 for his many years of work surrounding LGBTQ issues. Anorve served on Long Beach's Citizens Police Complaint Commission and was a fellow with the Equality California Leadership Program. The mayor appointed Anorve to the Long Beach Ethics Commission. (Harvey Milk Promenade and Equity Plaza.)

Rev. Dusty Pruitt's name should be added to the wall in Harvey Milk Promenade and Equality Plaza. She pastored the Metropolitan Community Church in Long Beach for 15 years. During that time, she also served with the Army Reserve. When her commanding officer learned she was a lesbian, her promotion to major was taken away, and she was discharged. The ACLU and the Lambda Legal Defense and Education Fund took her case which was settled in her favor in 1995. She was reinstated and given her promotion. She retired from the Army Reserves and married her longtime partner, Joanne Rhodes, in 2008. They are living in Santa Fe, New Mexico. (Left, Dusty Pruitt; below, VA News.)

Mina Kay Meyer (seated) and Sharon Raphael were one of the most formidable lesbian couples in Long Beach. They met as children in Ohio and then reconnected in California, dated, and stayed together for the next 45 years. Mina was the cofounder of AIDS Hospice Committee and AIDS Hospice Foundation and the Director of the Gay Women's Service Center, which was the first for lesbians in the United States. They moved to Long Beach in 1983 and became involved in city politics working with Long Beach Citizens Involved and Lambda Democratic Club. Mina served for nine years on the Long Beach Human Relations Commission. She volunteered for Marriage Equality California. As gerontologists, they worked to bring the concerns of older lesbians to the forefront by organizing a Southern California chapter of OLOC (Old Lesbians Organizing for Change) and a Lez Chat at the Center. Mina died in 2016. Their names were added to the Harvey Milk Promenade and Equality Plaza in 2018. (Sharon Raphael.)

Phillip Zonkel is a pioneering and award-winning journalist. He has a track record of bringing LGBTQ+ news out of the closet. At the *Press-Telegram*, he was the only reporter in the paper's history to have a beat covering the city's LGBTQ+ community. His muckraking journalism won him two awards, and he received a nomination for his reporting, including a two-part investigation that exposed anti-gay bullying of local high school students and the school district's failure to implement state-mandated protections for LGBTQ+ students. He has written several articles on the Long Beach Police Department's history of falsely arresting gay men for lewd conduct. He also is the publisher and cofounder of *Q Voice News*, a groundbreaking publication that created a new space in the Long Beach media ecosystem. It is the only digital-first LGBTQ+ news outlet in the area and serves a vital need for the community. (*Q Voice News*.)

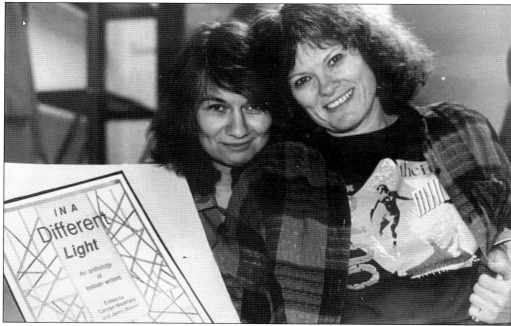

In 1984, Jenny Wrenn (left) and then-partner Carolyn Weathers founded a lesbian book company called Clothespin Fever Press, publishing 25 books and 55 authors. Their anthology of lesbian writers from Ann Bradley's Lesbian Writers Series was an award winner from the American Library Association. Weathers and Wrenn were both librarians and involved with many lesbian and feminist issues. Wrenn was also a newspaper photographer, artist, and writer. (Carolyn Weathers.)

There were a few courageous straight allies, who stood up for and with the lesbian and gay communities from the beginning in the 1970s, 1980s, and 1990s. Some initially served on the Long Beach City Council: Wally Edgerton, Marc Wilder, Renee Simon (right), Evan Braude, and Alan Lowenthal. Some served on the Long Beach Unified School District Board of Education, as did Jenny Oropeza (right) and Bonnie Lowenthal. Jenny Oropeza later served on the city council and in the Assembly and Senate. Bonnie Lowenthal also served on the city council and in the Assembly and Senate. Alan Lowenthal served in the Assembly, Senate, and US Congress. (Right, Historical Society of Long Beach; below, California State Senate.)

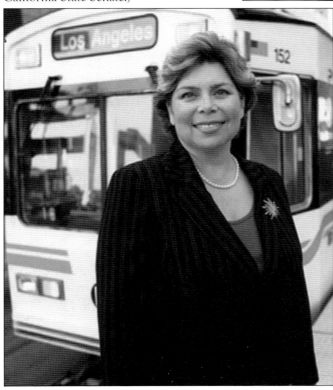

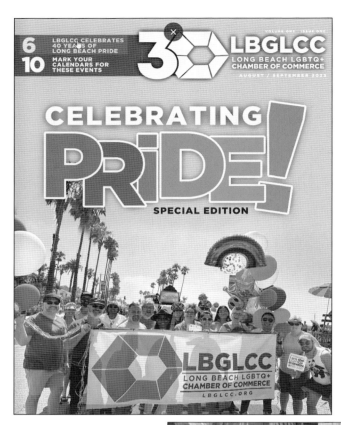

The Long Beach Community Business Network was founded in 1992 by gay and lesbian business owners to serve as a networking and support organization for gay-owned and gay-friendly businesses within the greater Long Beach area. Since then, the organization has grown to include businesses from surrounding areas. In 2001, the organization's name was changed to the Long Beach Gay & Lesbian (LBGL) Chamber of Commerce. (LBGL Chamber of Commerce.)

Visit Gay Long Beach connects business, leisure, and family travelers with LGBTQ+ and ally-owned attractions, events, entertainment, and restaurants in Greater Long Beach. Its goal is to provide LGBTQ+ visitors with inclusive, safe, and unique experiences to ensure that every trip is pleasurable and memorable. Visit Gay Long Beach offers businesses a free You Are Welcome Here sticker to display on their storefronts. (Visit Gay Long Beach.)

July is Disability Pride and Empowerment Month because the Americans with Disabilities Act was signed into law in July 1990. Since 2022, an annual event has been held at the Harvey Milk Promenade and Equality Plaza to highlight the "intersectionality" of the 46,000 members of the disabled community and to provide visibility for their issues. (JustinRudd.com.)

Trans Pride Long Beach was started in 2020 as a one-day event to highlight, empower, inspire, and normalize the vibrant "Trans and Nonbinary" community, and to show strength in unity with trans folks and their allies. The 2023 event featured several trans performers, including Ryan Cassata and Ezra and the Pussyboys. (Q Voice News.)

Jan Fischer Burke received Lambda Democratic Club's first "Outstanding Woman" award during its Human Rights Awards Banquet in 1980, Burke served as the organization's first chair of its political action committee and accompanied a large contingent of gays and lesbians to the state Democratic convention. Burke started a support group for bisexual women and was a cofounder of the Women's Union. She also conducted oral history interviews for the *Rosie the Riveter Revisited* series. The interviews were the first of their kind and contributed to understanding the meaning of women's wartime work. Transcripts of the interviews are archived at CSULB. Burke was a columnist for the *Press-Telegram*. In 1988, she married Tim Burke. From 1993 to 2013, Burke authored several best-selling murder-mystery novels and short stories. When asked what he was reading after his inauguration, President Clinton remarked *Goodnight, Irene*, Jan Burke's first novel. (Jan Burke.)

Lorna A. Albertsen, pictured left with Historical Society of Long Beach executive director Julie Bartolotto, was the first lesbian to serve as president of Long Beach Lambda Democratic Club from 1982 to 1985. In 1983, the club honored her as its "Outstanding Woman." Albertsen frequented the Que Sera and recruited entertainer Melissa Etheridge to promote Blood Sisters Blood Drive. She continued her activism in the Palm Springs area as a board member of Desert Stonewall Democrats. In 1985, Albertsen led Lambda's public campaign against the Federated department store chain and threatened a boycott after they fired a sales associate for being gay. Albertsen has spoken out repeatedly against anti-gay businesses such as Chick-fil-A, which has a lengthy history of donating to anti-LGBTQ organizations, including those that had opposed same-sex marriage and anti-discrimination protection for LGBTQs. During COVID, she publicly criticized the Riverside County sheriff for opposing state public health mandates. (Lorna Albertsen.)

Flo Pickett (pictured on the left) was an early member of the Long Beach National Organization for Women and the Long Beach National Women's Political Caucus. As president of Long Beach NOW, she led the chapter in supporting CSULB women's studies instructors and program chair Dr. Sondra Hale (pictured on right), who were under siege from the right wing. Pickett was one of the first local realtors to specialize in assisting and supporting the lesbian and gay community. She was honored by Lambda Democratic Club as its "Outstanding Woman" in 1989. Pickett met Gerrie Schipske in 1979 while serving together on the YWCA Board of Directors. They became partners and raised three children. In 2017, they legally married. They are raising a granddaughter. (Author's collection.)

In 2023, in partnership with Elders Rising and the Historical Society of Long Beach, the Arts Council for Long Beach (ArtsLB) announced a new citywide public arts program, Rainbow Heroes. This groundbreaking initiative focuses on telling the stories of LGBTQIA+ elders through interactive murals that will be placed in all nine city council districts. The interactive nature of this innovative project (pictured) comes in the two rainbow arches—one will sit above the portrait of the LGBTQIA+ figure, and the other will be blank to allow visitors and residents to stand underneath it and be a part of that elder's story. Translations in Spanish, Khmer, and Tagalog will also be available, ensuring inclusivity and accessibility for all. The public was asked to nominate LGBTQIA+ elders they want to see recognized through this program and on murals throughout Long Beach. (Rainbow Heroes.)

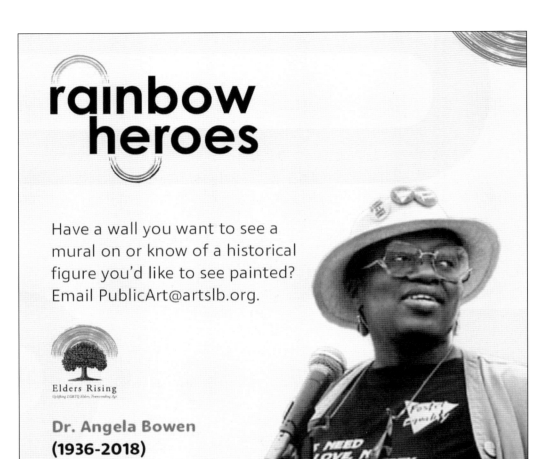

rainbow heroes

Have a wall you want to see a mural on or know of a historical figure you'd like to see painted? Email PublicArt@artslb.org.

Elders Rising
Uplifting LGBTQ Elders, Transcending Age

Dr. Angela Bowen
(1936-2018)

The first honoree in the Rainbow Heroes project is Dr. Angela Bowen, a dance icon, activist, and professor at California State University, Long Beach. Bowen advocated for the rights and representation of marginalized communities, including women, people of color, and the LGBTQIA+ community. Her life is the subject of the documentary *The Passionate Pursuits of Angela Bowen*, produced by her former partner Jennifer Abod, a feminist activist, singer, filmmaker, and journalist. Abod was a cofounder and the singer of the New Haven Women's Liberation Rock Band from 1970 until 1976. Dr. Abod taught women's studies at the University of Massachusetts Boston and CSULB. She was a media specialist at Digital Equipment Corporation and the first woman in Connecticut to host a nightly AM radio talk show, *The Jennifer Abod Show* on WELI-AM. (Above, Rainbow Heroes; left Jennifer Abod.)

Ten
Creating a LGBTQA Cultural Center

In 2016, the City of Long Beach Public Works Department finished painting rainbow-colored continental crosswalks along the Broadway Corridor. These crosswalks are symbols of pride and were chosen to increase public visibility and safety for drivers, pedestrians, bicyclists, and skateboarders as they cross the intersection. The crosswalks were updated in 2018. (City of Long Beach.)

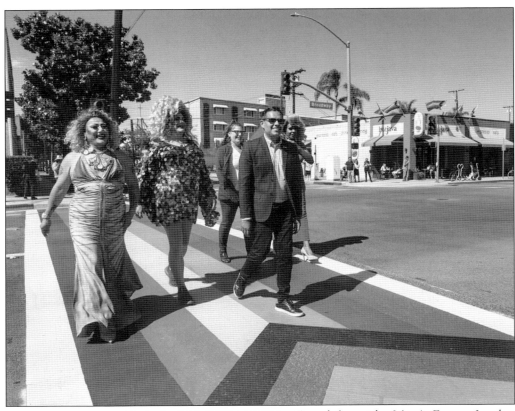

From left to right, Mia A. Farrow, Jewels, Mayor Robert Garcia, Councilwoman Cindy Allen, and Sashay Couture walk across the updated pride crosswalks during an unveiling at the intersection of Broadway and Junipero Avenue in Long Beach, California, on Thursday, June 30, 2022. The crosswalks are located at Broadway and Junipero Avenue and intersections of Broadway and Newport, Cherry, Falcon, and Orange Avenues. (City of Long Beach)

In June 2022, the Long Beach City Council unanimously approved a recommendation brought forth by then-mayor Robert Garcia and cosponsored by Vice Mayor Cindy Allen. It directed city staff to work with community stakeholders to create a visioning process and feasibility plan for the LGBTQ+ Cultural District. (City of Long Beach.)

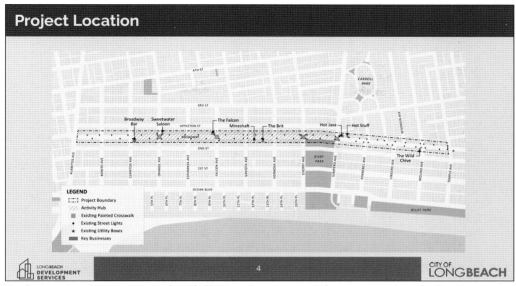

By designating the area as a cultural district, the city says it hopes to work with the community to educate visitors about the cultural and historical significance of the LGBTQ+ community in the neighborhood, support the LGBTQ+ businesses and institutions in the district, and invest in public improvements to ensure the LGBTQ+ community continues to thrive. (City of Long Beach.)

City staff met with stakeholders and the public to solicit feedback and develop concepts to help guide a vision for the establishment of the LGBTQ+ Cultural District. This area of the city is home to many of Long Beach's gay bars and LGBTQ+ businesses, such as Hot Stuff, which opened in 1980, as well as being a longstanding, important gathering place for the LGBTQ+ community. (Hot Stuff.)

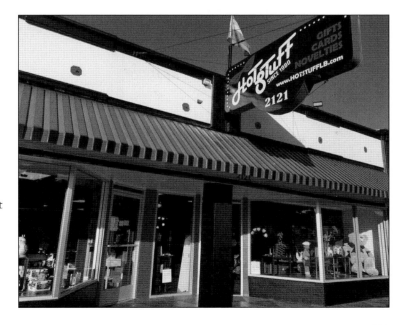

The Park Pantry is one of the oldest businesses in the proposed cultural district. It opened in 1956 across the street from Bixby Park on Broadway and Junipero Avenue. The restaurant serves the neighborhood and is a meetup place for those visiting the local bars. Directly across the street from the restaurant is Hot Java, a coffeehouse opened in the late 1990s by lesbian activist Marsha Naify. (Park Pantry.)

Northalsted – Chicago, IL
https://northalsted.com/

Formerly known as Boystown, the Northalsted Business Alliance is a chamber of commerce that was established in 1982 with a mission to improve economic vitality and quality of life through programs and services that celebrate the LGBTQ+ community. The organization organizes attractions including a pride art and history tour, festivals, and community events. Within the neighborhood there is a special taxing district that provides funds to address the concerns of property and business owners such as street landscaping, waste receptacles, and seasonal decorations.

In June 2023, the city released the Preliminary LGBTQ+ Cultural District Report for public review detailing the community's history and outlining the next steps for the initiative. It included suggestions received for neighborhood- and business-led activation opportunities. The report reviews several other established LGBTQ Cultural Districts in San Jose, California; Northalsted-Chicago, Illinois; and Montreal, Canada as models for Long Beach. (City of Long Beach.)

Four hundred ninety-five people responded to a survey about the proposed cultural district. They listed their priorities for the project to include art installations, murals, historical plaques, decorative lighting, streetlight post banners, better street lighting, improved business density, non-police safety ambassadors, homeless support, and increased pedestrian activity. (City of Long Beach.)

Examples of community- and business-led efforts that were suggested included "Business Improvement Initiatives, Digital Calendar, Host new and ongoing LGBTQ+ events in the Broadway District, Develop hyperlocal neighborhood and business associations, Join the Long Beach LGBTQ+ Chamber of Commerce (LBLGCC), Implement Sidewalk Dining and Parklets, Complete the Public Mural Process, and Neighborhood Adopt-A-Tree." (City of Long Beach.)

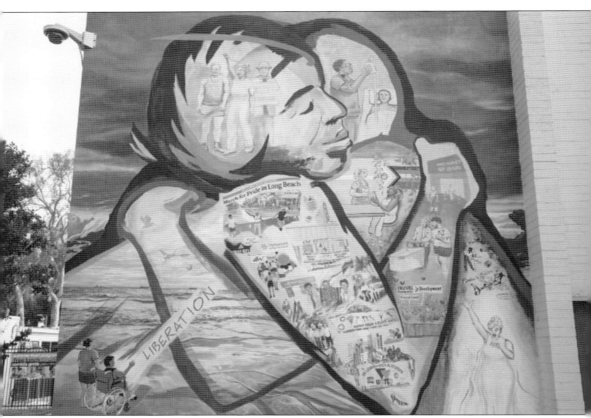

Bixby Park, historically a large gathering space for LGBTQ+ events, is part of the proposed cultural district. It is also the site of the 2023 installed mural titled "Long Beach Embrace," celebrating the LGBTQ+ community. The mural was painted on cloth and designed by Myisha Arellano, a queer, migrant artist born in Mexico City and raised in LA County. The mural includes a collage of scenes of people and events significant to the Long Beach LGBTQ community. It was commissioned by the Los Angeles County Commission on Human Relations initiative LA vs Hate: Summer of Solidarity, in partnership with the LGBTQ Center Long Beach. Additional supporting partners include Long Beach Human Dignity Program, Vice Mayor Cindy Allen's office, Long Beach Parks & Recreation, and the Museum of Latin American Art.

The city hosted a meeting in September 2023 to gather input on the initial recommendations for the cultural district. The final report will contain recommendations that were shaped and then later refined by the community. This plan was presented to the mayor and city council in fall 2023 and offered the opportunity for recommended next steps for implementation, including developing designs for the district using the report, identifying funding sources such as city funds, applying for and accepting grants, and selecting a contractor to install and construct prioritized improvements in the district. It is expected to take several years from approval to completion. (Both, City of Long Beach.)

LGBTQ Resources

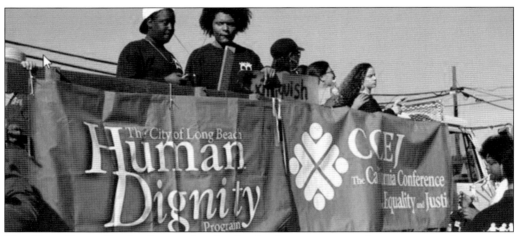

The City of Long Beach, along with other levels of government and many non-profit programs covering Long Beach, offers specific benefits and services for its LGBTQIA+ residents:

- Long Beach Health and Human Services Department offers services and resources for the entire community, including HIV early intervention, testing, counseling, education, and comprehensive planning. (longbeach.gov/health/services/clinics/hiv-aids-clinic)
- Human Dignity Program was established to combat discrimination and improve education and cooperation among residents. To join the program, to learn more, or to report a hate crime or other discrimination, please call (562) 570-6948.
- Long Beach Pride offers programs, events, and charitable works designed to benefit the LGBT community and educate all community members. (longbeachpride.com)
- The LGBTQ Center Long Beach, located at 2017 East Fourth Street, is a hub of LGBTQ resources and services for Long Beach. The Center offers informational programming, group therapy, youth programs, job and apartment listings, and more. (www.centerlb.org)
- St. Mary Medical Center's CARE Program provides an array of programs and services for those infected and affected by HIV/AIDS, from Medical and Dental Services to Case Management. (www.facebook.com/CAREProgram)

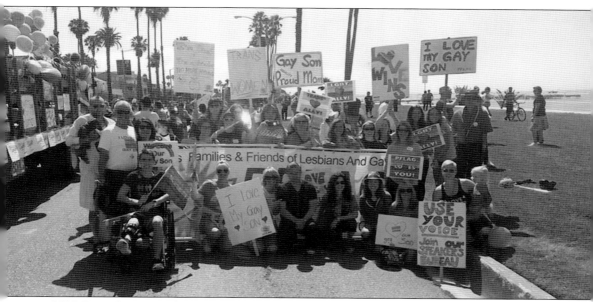

- CSULB LGBTQIA—the Lesbian, Gay, Bisexual, Transgender, Queer, Intersex, Asexual + Campus Climate Committee (LGBTQIA+CCC)—collaborates with all segments of the University to recruit, retain, and promote the success of LGBTQIA+ students, staff, faculty, and administrators. (cla.csulb.edu/lgbtqia)
- Long Beach Parents and Friends of Lesbians and Gays provides support for families, allies, and people who are LGBTQ. (lbpflag.org)
- The Trevor Project provides phone, text, or chat anytime whenever LGBTQ young people are thinking about suicide or feeling lonely. (thetrevorproject.org/get-help/)
- Trans Lifeline is the nation's only crisis and peer-support hotline, staffed by trans people, for trans people. (translifeline.org)
- The Queer Space Club at Long Beach Community College exists to offer a place of refuge for all LGBTQ+ students. (lbcc.edu/lgbtq-resources)
- Long Beach Unified School District LGBTQ Student Resources provides access for parents, guardians, and other family members of LGBTQ+ youth the resources they need to ensure their LGBTQ+ children are protected and supported. (lbschools.net/departments/student-support-services/lgbtq-students-and-resources)

Discover Thousands of Local History Books Featuring Millions of Vintage Images

Arcadia Publishing, the leading local history publisher in the United States, is committed to making history accessible and meaningful through publishing books that celebrate and preserve the heritage of America's people and places.

Find more books like this at
www.arcadiapublishing.com

Search for your hometown history, your old stomping grounds, and even your favorite sports team.

Consistent with our mission to preserve history on a local level, this book was printed in South Carolina on American-made paper and manufactured entirely in the United States. Products carrying the accredited Forest Stewardship Council (FSC) label are printed on 100 percent FSC-certified paper.